·Princely India·

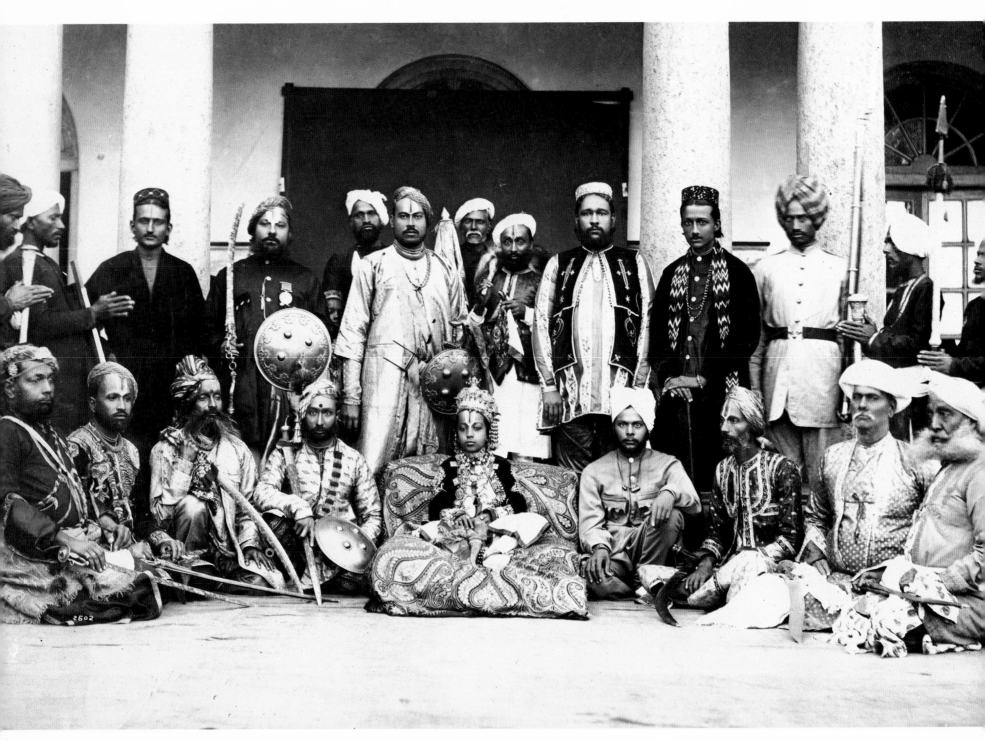

Child prince and courtiers, Central India, 1880's.

·Princely India·

Photographs by Raja Deen Dayal 1884-1910

Edited and with Text by Clark Worswick

Foreword by John Kenneth Galbraith

A Pennwick/Agrinde Book

Published with Alfred A. Knopf

New York, 1980

Acknowledgments

In producing this book on the life and times of Raja Lala Deen Dayal, I am indebted to several people, both in India and in the United States. In America, I am grateful to Carol and Ray Learsy for pursuing this project, often over the most difficult terrain, and to Martha and Larry Friedricks, who provided the initial inspiration for me to travel to India to discover whether any of the great nineteenth-century photographic firms were still extant. For years Porter McCray, Allen Wardell, Stuart Carey Welch, and John Rosenfield have encouraged me in my interest in India and given willingly of their time and expertise. Bob Adelman saw this book through, and I appreciate that. But were it not for the interest, concern, and care of one man this book would never have been done—Raja Amichand Deen Dayal, the grandson of Raja Lala Deen Dayal, is the single person who recognized and preserved the work of his grandfather in India, thus enabling all of us to be enriched by these photographs.

I should like to dedicate this book to David McCutcheon and Marilyn and Arthur Penn—great bright spirits—who have kept me going with the wit, intelligence, and charm they have brought to my cause. I owe them individually a debt that is impossible to pay.

Library of Congress Cataloging in Publication Data
Dayal, Deen. Princely India
1. Kahn, Mahbu Ali, Sir, Nizam of Hyderabad, 1866–1911—Iconography.
2. Hyderabad, India (State)—Court and courtiers—Pictorial works.
3. Hyderabad, India (State)—Kings and rulers—Iconography.
I. Worswick, Clark.
DS479.1.K57D38 1980 779′.9′95484035 79-3506
ISBN 0-394-50772-X
Manufactured in the United States of America
First Edition

Foreword

Nothing so serves human vanity and the desire for at least a fingerhold on immortality as the thought of a pictorial record. For all time to come, people will know the physiognomy, progeny, or attire of this person and the exceptional size or number of the fish he has caught. It occurs to few, if any, that posterity is somewhat more likely to react to the eccentricity of appearance or the quaintness of the whiskers or the general primitiveness of the architecture. We admire ourselves and our time; we expect all who come after to share our good taste.

The urge for a permanent pictorial legacy has always been especially marked among kings and princes. Vanity and the urge for immortality have rarely been lacking in these precincts. But never were these so powerful as in India in the courts of the Great Moguls—Akbar, Jahangir, Shah Jahan—and among their imitators and successors. In Europe, court painters did portraits

Gold medal awarded to Raja Lala Deen Dayal, Jaipur Exhibition, 1883.

and family scenes and gave their impressions of battles, if won. In the Mogul courts and, after their decline, in the princely courts, large and small, painters concerned themselves systematically and repetitively with their ruler's person, women, courtiers, travels, recreation, and horsemanship. A sizable *atelier* was a requisite in every court, especially in Central, West, and Northwest India. The artists were, in the main, of humble station—their caste generally was on a level with that of carpenters. But many were of marked talent and some were inspired. They were not, of course, confined to portraiture and the exploits of their princes. Gods and goddesses, people and stories from the Hindu classics, figures from legend and myth, and varied, and on occasion exceptionally calisthenic, pornography were all subjects for their greatly diversified imaginations and talents.

In the history of art, disaster is held to have overtaken this great tradition toward the middle of the last century. There was a loss of artistic restraint; work was overdecorated and otherwise overdone. And to the courts of Central India, Rajasthan, and the Punjab Hills (the tiny principalities in the valleys in the southern foothills of the Himalayas where some of the best artists had worked for one hundred and fifty years) came harsh synthetic dyes that replaced the delicate ground-up earth pigments on which this painting had been based. And there came also the camera, which was the *coup de grâce*. This was a truly modern thing; what decent prince could advertise his obsolescence by retaining an old-fashioned painter? The artists, some of whom hastened their own departures by trying to imitate photographs in their painting, were, as it would now be said, "phased out."

It was indeed a calamity. But those who have written of this history have failed to notice that in one court it was a mitigated one. (As a minor writer on the subject, I share, in an appropriately small way, in the oversight.) That is the message of this book.

The fortunate court was the greatest and richest, though far from the most progressive in India, that of Sir Mahbub Ali Khan, the Nizam of Hyderabad. Here there was a wonderful achievement with the new art form. In 1884, Raja Lala Deen Dayal of Indore, already an accomplished cameraman, came to Secunderabad, the Nizam's capital, and was recognized for the genius he was and made photographer to the court, a position that allowed him money for workshops, cameras, plates, and a staff of several dozen assistants. From this position he proceeded to provide his patron, Sir Mahbub Ali Khan, with the distinction, then and forever, which painters and photographers are meant to provide and which, in the case of this ruler, would have been achieved in no other way. This collection of photographs, and their elegant arrangement by Clark Worswick, are part of the claim—almost certainly the most important effort at rescue Sir Mahbub Ali Khan will ever have. One hopes that it will do even more for the rather more deserving memory of Raja Lala Deen Dayal, a truly accomplished man. Let all notice the title "Raja." So highly regarded was his work in his time that not only did viceroys and other great figures seek him out, but his position endowed him with a feudal holding and a title—not a maha, or great, raja, but a raja nonetheless. Not many photographers, however worthy, have been ennobled for their art.

John Kenneth Galbraith

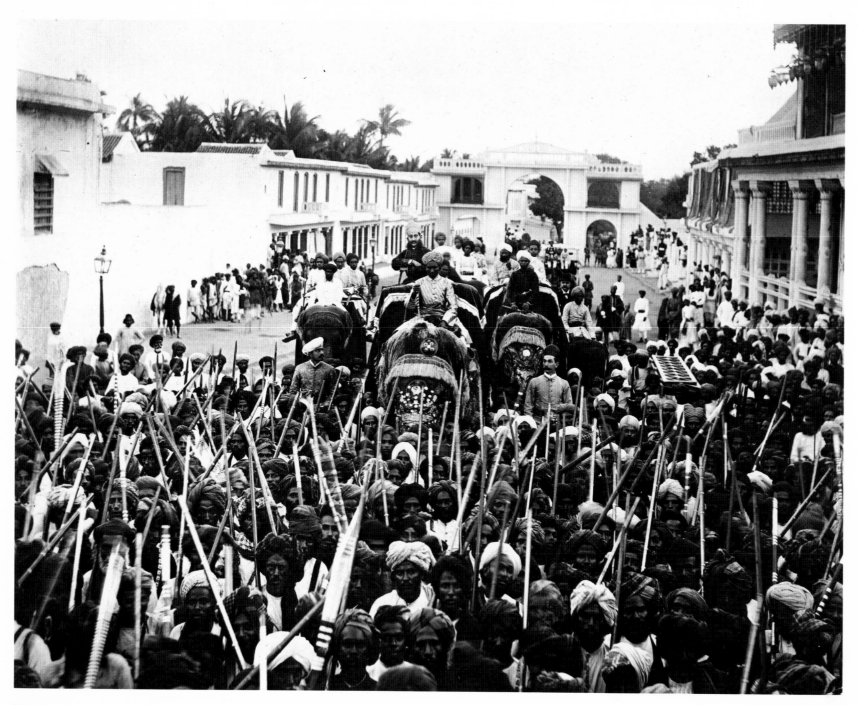

The Prince

In the mid-1880's, Queen Victoria's third son, the Duke of Connaught, visited the domains of the Premier Prince of India, the sixth Nizam of Hyderabad. After spending some time hunting in the finest tiger preserves the subcontinent offered, he asked his host, Sir Mahbub Ali Khan, if there was anything he could do for him. "Yes," replied the Nizam, who proceeded to explain that whenever he visited the Viceroy's *durbar** at Delhi he was forced to put up with the inconvenience of having to approach his elephant outside the railway station. How much simpler life would be if the elephant could approach him at his train! After all, he mused rhetorically, what was the purpose of having an elephant if one had to walk to reach it?

The Duke agreed to convey this sensible, modest request to the Viceroy, who, for political reasons, could not afford to have the Duke override his own imprimatur and stubbornly insisted that it was beyond even royal prerogative to countermand a direct viceregal order. So the matter rested until the next *durbar*.

In his private train, drawn by his most modern steam engine and staffed by members of his own State Railways, the Nizam drew up at the main platform of the Delhi station on a Monday morning. Dutifully his elephant waited, attended by its *mahout*, outside the station. A grand scene was about to be played out.

The Nizam, direct descendant of one of the most clever and ruthless Mogul adventurers of the eighteenth century,

*See Glossary on page 23

Opposite Sir Mahbub Ali Khan, the sixth Nizam of Hyderabad, with a contingent of his Arab irregular soldiers, 1890's.

was not about to yield to the Viceroy's intransigence. Having been exposed to the civilizing benefits of a British tutor in his palace, the Premier Prince settled down like a proper British gentleman calmly to await his elephant. He had his meals, tired of solitaire, played whist with his nobles, while Monday and Tuesday went past. Preparations for the *durbar* came to an abrupt halt, but so had the entire rail traffic of northern India since no trains could move in or out of the station. For hundreds of miles behind him, the trains of the 561 princes of British India waited.

On the third day, pressured by the mounting fury of his entire government, the Viceroy allowed the Nizam's elephant the fifty-foot access onto the main platform. Showing no sign of his victory, Sir Mahbub Ali Khan calmly mounted his elephant and rode toward his meeting with the Viceroy, where he swore allegiance to the Crown and the imperial presence as manifested by the gentleman with the singularly apoplectic appearance. [1]

This encounter epitomizes the peculiar relationship that existed between the native princes of India and the British Raj. Thwarted from exercising any real political power, the Indian princes devised ingenious ways to luxuriate in compensating glories. In order to understand fully their anachronistic position, it is necessary to explore the development of the British Raj itself.

By 1850, the British East India Company had created a unique commercial enterprise, with its own navy and army (several times larger than the British Army) that proved capable of uniting what now comprises Sri Lanka (Ceylon), Burma, Bangladesh, Pakistan, and India. It was a company that conventionally paid dividends to its shareholders, virtually "owned" a subcontinent, and reserved to itself the right to make peace or war there.

In 1858, after its Indian troops mutinied, the British East India Company's hegemony passed into history, to be replaced by the formal rule of the British Government. Gradually, during the next twenty years, there evolved in India a government that was the set piece of the Empire—the British Raj. The newly appointed Viceroy was Queen Victoria's personal representative and became both the administrative and symbolic center of colonial power. To soothe local sensibilities, the subcontinent was divided into British India and Princely India. There were important distinctions between the two. British India comprised all the territory that the British East India Company had gobbled up in its 257-year history, encompassing 59 percent of the subcontinent, or eleven provinces. Princely India covered an area slightly larger than 40 percent of the subcontinent, consisting of 562 native states ruled over by a variety of maharaos, rajas, maharajas, et cetera, and a single Nizam, who was the ruler of the largest and richest of the princely states, Hyderabad.

The princes owed their continued existence to early alliances made by the British East India Company during its struggle to become the paramount power on the subcontinent. But after 1858, as the price of being confirmed in their states, the ruling chiefs and princes were compelled to hand over to the British Government in India all rights to an independent foreign policy. What this meant ultimately was that the native princes had abdicated the right to wage war. These martial families, whose forebears had lived exclusively for war, were

now reduced, by virtue of one clause in a treaty, to life as hothouse vestiges of a grand, if brutal, tradition.

A story concerning the ownership of the Koh-i-Noor diamond gives a rare insight into the private feelings of a native prince toward the British usurpers of his martial heritage. Mined at Golconda, the diamond was the great treasure of the Moguls. At the time of the sack of Delhi by the invading Persian ruler Nadir Shah in 1739, the diamond passed through an ocean of blood, finally reaching the treasury of Ranjit Singh, the last independent ruler of the Punjab. When Jean-Baptiste Tavernier, jeweler to the court of France, had seen the diamond in the treasury of the Moguls in 1665, it had been cut from its original 756 carats to 268 carats; at the time it was acquired by Ranjit Singh it weighed 186 carats. A year after the British East India Company annexed the Punjab in 1849, the stone was "presented" to Queen Victoria. With regal insensitivity, the Queen invited Dhuleep Singh, the deposed heir of the now defunct kingdom of the Punjab, to visit her at Windsor Castle to view the diamond which had been further diminished to a lean 106 carats. When asked if he recognized the fragment of the (then) largest diamond in the world, the prince took the stone over to a window and studied it for fifteen minutes; he then handed it back to Her Majesty, expressing "deep pleasure at being able to place it in her hands." Thereafter, the prince allegedly referred to Her Majesty privately as "Mrs. Fagin," saying, "She is really the receiver of stolen property. She had no more right to that diamond than I have to Windsor Castle." [2]

In the latter half of the nineteenth century, princes who were formerly raised in the traditional styles of Indian life began to be educated under the supervision of British tutors and in special colleges set up for the scions of royal houses. The earlier princes' aspirations had been to equip their armies with the most modern weapons and wage endless wars on their rivals; their sons' ambitions were to increase the number of guns in their salute (among the 562 native states, only 149 had the princely recognition of a ceremonial salute; of these, five rated a twenty-one-gun salute and six, a nineteen-gun salute), and to equip their garages with the most up-to-date equipment from Mercedes Benz. Though their forebears had been afraid to "cross the black water" and lose caste, sons and grandsons took up residence in London at the Savoy and Claridge's and sometimes stayed for whole generations.

The resultant life-style of these Indian princes in England was a modern press agent's dream. Fabulously wealthy, many of the princes formed liaisons with a dizzying array of manicurists, schoolgirls, night club entertainers, and American women of "doubtful antecedents," and the penny press described how Bond Street would be ravaged periodically by agents of the "richest man in the world," the Nizam of Hyderabad (who never left India).

Of all the princes, great and small, the family of the Nizams of Hyderabad is one of the most fascinating. The last survivors of the Mogul Empire, directly descended from Asaf Jah, an eighteenth-century Turkoman adventurer in the employ of the last great Mogul emperor, Aurangzeb, the family's power was centered on the ancient kingdom of Golconda, in Central India. The rise of Asaf Jah exemplifies that of many of the ruling princes. By cutting his way through the ruins of the Mogul Empire after Aurangzeb's death, Asaf Jah

managed, through a combination of wit, audacity, and longevity, to become first the Mogul viceroy of the richest Mogul province, Hyderabad, and then to establish his own ruling house at Golconda. Here, with a population that was 90 percent agrarian and Hindu, the Muslim Nizams of Hyderabad became the pivot upon which the fortunes of India revolved in the most literal way—for the mines of Golconda provided most of the world's supply of gem-quality diamonds. When the British unlocked Hyderabad in the mid-eighteenth century, it was the *coup de main* which established the family's rule first of Central India, then of the subcontinent. One result of this was that the Nizam became the first Indian prince to gain the dubious distinction of housing a British Resident attendant at his court. After the Mutiny of 1857, the Nizam emerged as the Premier Prince of India and ruler of the richest native state. More important, the house founded by the Mogul adventurer Asaf Jah became the ultimate preserver of Muslim princely traditions in India. (As the last of these great princes, the family was considered semi-divine, and as recently as 1960, the seventh Nizam still bestowed Mogul titles on courtiers of merit.)

During the high Victorian period, Hyderabad was marked by the charismatic presence of the sixth Nizam, Sir Mahbub Ali Khan, who kept the most exotic and lavish court in India. Born in 1866, he became the sixth Nizam of the Asaf Jah line at the age of three, upon his father's death. A regency was established for the young Nizam until he came of age in 1884. The Viceroy, Lord Ripon, traveled to Hyderabad for the investiture, gave the young prince a lecture on fiscal responsibility, buckled a diamond-hilted sword about him (on the wrong side) and departed.

Neither the resources of the Nizam nor the times in which he lived particularly encouraged royal parsimony. Hyderabad soon became internationally noted for Mahbub Ali Khan's extravagant entertainments and royal hunts. The dazzling roster of aristocratic visitors to Hyderabad during the early years of the sixth Nizam's rule included the future Czar of Russia, Archdukes of Austria and a Grand Duke of Russia, the Duke of Connaught, and assorted German princelings, all of whom enjoyed the luxurious game preserves that held every kind of beast including the Nizam's private stock of tigers. These game parks were reached by the Nizam's private railway, which spanned eight hundred miles of his domain. Occasionally, though, non-royal guests would arrive at the Nizam's private railway station and board the royal train, only to await their oblivious host for days. These unfortunate souls would camp out on the train, while a full head of steam was maintained for His Highness' imminent arrival. Eventually, Abid, the Nizam's indispensable gentleman of the bedchamber, would appear, signaling the long-awaited appearance of the Nizam, who would arrive with great panoply by royal carriage or astride one of his eight hundred Arab Thoroughbreds.

At the chosen site for the hunting camp, the beat was as carefully managed as a military campaign. Hordes of peasants were enlisted to flush out game for the hunters, while the royal party potted away with their high-powered rifles. The Nizam, reputed to have been India's finest shot, cannot have found it much of a challenge. Once, to amuse himself during the visit of the ill-fated Archduke Franz Ferdinand of Austria,

he demonstrated his marksmanship by shooting small coins tossed into the air.

Despite his appearance as a perfect Victorian gentleman, with tailored wool suits and a gold-topped walking stick, Sir Mahbub Ali Khan never left India and had few European intimates. He spent his early life, like many of the princes of India, dominated by the women of the *zenana* (the women's quarters of the palace). These Muslim princesses were the most traditionalist and most anti-British females in India, withdrawn in the grand shadow of this last great Muslim Indian kingdom. Countering their influence on the young Nizam was the impressive bulk of one of India's foremost statesmen, the Prime Minister of Hyderabad, Sir Salar Jung. Before his death in 1883 (from a surfeit of canned oysters consumed at a picnic), the Prime Minister, a Shiite Muslim, was the perfect foil against the intrigues of the *zenana*. He was both practical and competent. He had rescued the fifth Nizam from bankruptcy when the crown jewels were about to be pawned to the city's moneylenders. While the princesses were narrow-minded and obsessed with preserving the faded glories of the Mogul era, Sir Salar Jung was progressive. To prepare the young Nizam for his majority, the Prime Minister engaged a British tutor, one Major Clerk, the only European with whom the young Nizam is known to have developed a close relationship. Employed to teach the Nizam the subtleties of the world beyond Hyderabad, the Major did such a competent job that he incurred the wrath of the British Resident, John Cordery. The latter accused Clerk of encouraging his pupil to interfere in affairs of state, quite unacceptable in the British view. Major Clerk was dismissed, and any possibility of a European account of the day-to-day life of the sixth Nizam's court vanished.

Since the Nizam had few intimates, the nature of his character can only be pieced together from the anecdotes of British Residents or from the casual notes of touring members of European aristocracy. All these sources concur in describing the Nizam as a "perfect gentleman." He is called "delightful," "shy," "great company," and said to have had a splendid sense of humor. He was also an excellent polo player, a crack shot, a generous host, and one of the richest men in the world. Despite his fabulous wealth, the sixth Nizam never permitted himself the excesses indulged in by some members of his family. His sister kept an armed bodyguard of amazonian women to look after her in her declining years, and his son, Sir Osman Ali Khan, the seventh Nizam, allegedly sired some two hundred children.

The single other source of information about the Nizam and his court is the detailed record kept for a quarter of a century by his personal photographer, Raja Lala Deen Dayal. The Nizam was one of the few Indian princes to appoint a photographer to work exclusively at his court; Dayal was regularly in attendance, documenting the ceremonies and dignitaries of court and camp.

In the 1890's, the population of the Nizam's territories exceeded fourteen million people and covered an area larger than England and Scotland combined. The territories were governed directly by *subadars, taalukadars, tahsildars,* and the occasional *raja,* but the Nizam had ultimate control over these minor nobles. The predominantly arid land was worked

by Hindu subsistence farmers, who were periodically reduced to conditions of famine by severe droughts.

Today, in an era of tame, constitutional European monarchs, it is difficult to imagine the power of a prince like the Nizam. The family of Asaf Jah sat atop a feudal pyramid, supported by fourteen million souls, to whom the Nizam was both a spiritual leader and a sovereign. The court of the Nizam was oriental in concept, and his *durbars* followed the tradition of a seventeenth-century Mogul Emperor. Attendant at the court were hosts of musicians, singers, and astrologers; the royal hunting staff; keepers of elephants, camels, and horses; members of the various government and judicial departments; and, finally, the *dewan* (Prime Minister) and his circle. Also in evidence was an array of Hyderabadi nobility, whose incomes were dependent upon the family of the Nizam for the upkeep of their palaces, lands, and retinues.

The administration of the Nizam's dominion was amazingly ecumenical for the nineteenth century. While the ruling family was Sunnite Muslim, Prime Minister Kishen Pershad was Hindu, the political secretary was a Parsi, two ministers were Shiite Muslims, and the heads of the Finance, Revenue, and Police Departments were British, on loan from the British Indian Service. The Nizam had the power of life and death over his subjects through his courts. In the countryside, he reserved to himself certain districts and the right to tax them. He also controlled the Kollur diamond fields, near Golconda. Here, in the mid-seventeenth century, Jean-Baptiste Tavernier, the French jewel-trader and adventurer, reported seeing sixty thousand men and women laboring to extract the gems. These diamond pits, which, according to tradition, disgorged

twelve million carats of diamonds into the world market, were nearly exhausted by the time of the sixth Nizam, and produced only a trickle of their early wealth. By then, however, their owner's treasure vaults were stocked with diamonds of every shape and hue.

Official duties crammed the Nizam's daily schedule. There was his private army to attend to, some fifteen thousand troops. There were numerous royal visitations, hunts, and the yearly administrative tour of his dominion, all duly recorded in Dayal's photographs. Periodically, famines and floods ravaged the countryside, requiring the Nizam's special attention. In addition, since it was widely believed that the Nizam could counter the effects of snakebite, thousands of stricken peasants flocked to his court annually seeking a cure. Every five years a new Viceroy was appointed in British India, and as he toured the subcontinent he would make the obligatory stop in the Nizam's dominion to visit Sir Mahbub Ali Khan. In his turn, Mahbub Ali Khan traveled to Delhi, to viceregal *durbars,* duly pledging allegiance to the Crown through a succession of Viceroys.

Each morning on arising, Mahbub Ali Khan was brought the "Kotwal's Diary," a daily report drawn up by the chief of his spies and household police. The diary detailed the intrigues of the palace and of his family, which numbered in the thousands. This record was a necessity as the Nizam's family was above the law of the state and subject only to the authority of the Nizam himself. Poisonings or insurrections were far more likely to originate in the prince's family than among his subjects outside the palace.

In the late nineteenth century, as political change in the

world began to dissolve the traditions of Islam, the Ottoman Empire, ruled from Constantinople, was gradually being dismantled and Arab nationalism was growing. Increasingly, Hyderabad became a conservative haven that attracted many Arab and other Muslim traditionalists. The Prince of Shihr and Mukalla from the Hadhramaut took up residence in Hyderabad, as did hundreds of fanatic *habashis* (black Somali Muslims) from Africa. The city began to appear more Arabian than Indian. Wilfrid Scawen Blunt, the British poet and Arabist, wrote, "Hyderabad is like a great flower bed, crowded with men and women in bright dresses, and with a fine cheerful air of independence, more Arab than Indian....Instead of the squalid back street and the pauper population of native Madras...many men carry swords in their hands, one sees elephants and camels in the streets, besides carriages and men on horseback." [3]

Despite his opulent, politically adroit career, Sir Mahbub Ali Khan remains an enigma. Haunted in later years by memories of the dark princesses of the *zenana* who raised him, he retreated more and more into the shadows of his palaces, where he wrote solitary, romantic *ghazals* in Persian. Descended from conquerors, Mahbub Ali Khan was unsuited to the role of captive prince. The great Mogul poet Mir presaged the Nizam's condition a century before: "Pent in between the earth and sky, we stifle in this cage where no breath of air can come...the song I sing, in season, out of season, heralds the news of my captivity." [4]

In a corner room of the Falaknuma Palace, His Highness Asaf Jah, Muzaffar-ul-Mulk-Wal-Mumilak, Nizam-ul-Mulk, Nizam uddaula Nawab Mir, Mir Sir Mahhub Ali Khan Bahadur, Fateh Jung, Sipha Salar, the sixth Nizam of Hyderabad and Berar, died on August 9, 1911.

The obituaries written at the time of Mahbub Ali Khan's death do not mention the final postscript of his reign. It concerns a diamond. Near the turn of the century the Nizam agreed to buy a fabulous 162-carat diamond from its owner, Jacob, a gem merchant. Time and again, there had been financial confrontations between the Nizam and the British who feared his excesses would bankrupt the state. This time the British Resident intervened, forbidding the Nizam to purchase yet another bauble. The Nizam ignored him and bought the diamond anyway, paying half the purchase price to Jacob. An impasse developed; the Nizam had the diamond, but he was not allowed to remit the outstanding balance. Finally, the angry Jacob took the Nizam to court. The suit ruined the diamond merchant, and the Nizam suffered the public indignity of having to appear in a formal British court to explain the circumstances of his default. This permanently soured relations between the Nizam and the British. The notoriety of the diamond made the Nizam, who was once so eager to own it, now reluctant to display it. Years later, the seventh Nizam, Sir Osman Ali Khan, found the Jacob diamond wrapped in a piece of ink-stained cloth, stuffed into the toe of one of his father's slippers. A base of gold filigree was made for the magnificent jewel. Finally, it was used for the purpose originally intended—as a paperweight for state documents.

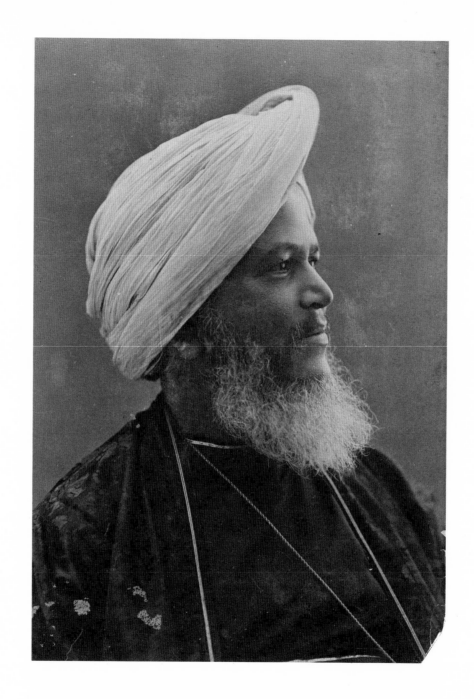

Raja Lala Deen Dayal, self-portrait, 1890's.

The Photographer

The early history of the photographic medium in India demonstrates substantial native Indian interest, with men of position and rank, even maharajas, taking up the new art with enthusiasm. In January, 1855, the first issue of the *Journal of the Photographic Society of Bombay* reported that "the Society already numbers upwards of one hundred members, the greater part of whom are Residents and men of influence." [5] A later issue highlighted the growing interest in the field with advance notice of *The Indian Amateur's Photographic Album*, the first photographically illustrated periodical produced in Asia. [6]

Oddly, although amateur interest in photography during the nineteenth century was great, active native Indian professional photographers were rare. Across the subcontinent, a commercial photographer would open a studio, thrive a few years, and then disappear. The names of Gampatrao Kale of Bundi, R. Jahalboy of Karachi, and Gobindaram and Codeyram of Rajasthan have survived, along with a few of their photographs, but most Indian professional photographers of the time have been consigned to oblivion. In the princely native states, essential royal patronage was seldom available.

In those few courts which had sufficient revenue and interest to sustain the time-honored traditions of the Indian court painter, the native photographers had to contend with

the social snobbery that dictated periodic visits by the princes to British photographic firms based in Calcutta. Perhaps this tradition, more than anything else, doomed the emergent Indian photographer. Yearly the princes would make their almost obligatory trip to Calcutta for the social season, when it was customary for them to be "done" by either Bourne & Shepherd or Johnston & Hoffman. These firms were so large, well-equipped, and prestigious that it was impossible for a small Indian firm in a native state to compete.

To the middle-class Indian, photography was viewed as an accoutrement of the affluent Englishman and a sign of a socially progressive Victorian. As such, it held an irresistible appeal to those Indians whose need for status required acceptance by the British and emulation of their values. Both the Indian aristocracy and the Indian bourgeoisie sought the same vehicle of social advancement—adding a curious twist to the introduction of photography to India. With the growing popularity of this new and fashionable art form came the inevitable, sad decline of the Indian painter. Lacking the financial and technical flexibility of his European counterpart, the Indian artist tried to accommodate his craft to the trend by slavishly imitating the photographer and producing second-rate, cameralike paintings with neither the immediacy of the photograph nor the insight of a genuine work of art. Tragically, by the mid-1850's, Indian artistic traditions, which had flourished for centuries, simply died.

Unique against this background is the surprisingly suc-cessful career of Raja Lala Deen Dayal, court photographer to the sixth Nizam of Hyderabad. His comprehensively detailed photographic chronicle of every aspect of Anglo-Indian life during the last quarter of the nineteenth century affords us a brilliant glimpse into a now defunct era. It is a legacy comparable with miraculously preserved remains of an ancient, abandoned city. By blending the artistic vision of an Indian painter with the realistic observation of the camera, Dayal became the pre-eminent indigenous photographer of nineteenth-century India.

About Dayal, an Indian critic of the time wrote:

They [other Indian photographers] do not bestow on their work the necessary amount of patience and care. As a consequence, therefore, native productions with very few exceptions do not possess such a good reputation as those turned out by the European firms. The best photographs turned out by a native of India are the Indian views executed by Lala Din [sic] Dayal of Indore.[7]

Born in Sardhana in 1844, Dayal received the technical part of his education at Thompson's Civil Engineering College in Roorkee, in the North-Western Provinces, after which he put his training to use as head estimator and draftsman in the Public Works Department at Indore.[8] In this capacity, he came in contact with the Maharaja of Indore, Tukoji Rao II, and other prominent figures willing to subsidize his early photographic endeavors.

In his memoirs, Dayal writes:

In 1874 I began to study photography as an amateur, and was greatly encouraged in my efforts by Sir Henry Daly, K.C.B., C.I.E., G.C.O.,[9] who was ever ready to patronize and help me as far as possible; through him I was able to secure a group of Lord Northbrook [the Viceroy] and friends during his visit to Indore and also a group of H.R.H. the Prince of Wales (and the Royal party in 1875–6).... Having found that the public greatly appreciated my views and a consequent demand for them having arisen, I took [a] furlough for two years in order to complete my series. Whilst at Simla I again secured two groups from H.E. the Viceroy (Lord Dufferin)—a family group and a "Legislative Council" group, in addition to a group of Sir Frederick Roberts, V.C. [being nominated for photographer to H.E. the Commander in Chief in India].... In 1884 H.R.H. the Duke of Connaught visited [the] Mhow Camp Exercises and I was appointed photographer to H.R.H.[10]

In the course of his massive photographic documentation of India's archaeological heritage,[11] Dayal had visited Hyderabad, where he chanced to take several photographs of the Nizam taking the salute of his troops. When the pictures were printed, Dayal presented them to the Nizam. This simple, unpremeditated gesture resulted in Dayal's appointment in 1884 as court photographer to the Nizam and his acquisition of a nobleman's house purchased by his patron. Thus began a unique collaboration that would last for over two decades between the richest, most powerful prince in India and the man who would immortalize him. In the Nizam, Dayal had encountered a patron whose tastes were reminiscent of the great Mogul princes of sixteenth- and seventeenth-century India and a setting which was in fact the last surviving remnant of the Mogul Empire.

Adding to the honors already conferred upon him by the Maharaja of Indore and the British government, the Nizam dubbed Dayal with the euphonious but untranslatable title "Raja Musavir Jung," which means roughly "bold photographic warrior." In 1894, while relaxing on a hunting expedition, the Nizam penned this overblown couplet to Dayal:

In the art of picture making, skilled surpassing all—
A master of masters is Lala Deen Dayal.

In addition to performing the myriad official duties of a court photographer, such as photographing military operations, royal hunts, state tours, weddings, religious ceremonies, viceregal tours, visits by foreign royalty and thrice-weekly *durbars*, Dayal operated his own commercial photographic establishments in Secunderabad and Indore.[12] By 1896, he had expanded his business and opened the largest photographic studio in Bombay, called simply "Raja Deen Dayal & Sons." In his employ at the three branches were over fifty people engaged in photographic and finishing procedures, supervised by his two sons, Raja Gyan Chand and Lala Dharam Chand. In Secunderabad, the Nizam's capital,

he opened a special "zenana studio for female photography," headed by Mrs. Kenny-Levick, a British lady whose husband was a correspondent for *The Times* of London and who also edited the local *Deccan Times*. [13]

In the last years of the nineteenth century, governors, generals, native princes, touring statesmen, and local business, artistic, and scientific personages all trooped to Dayal's Bombay studio to be "done." Sittings of important people were the exclusive domain of Dayal, whose customers insisted upon and received the attention of the Master.

For a period of six years (1898–1904), Dayal and his family managed to occupy a pre-eminent position in the Indian photographic world. But in 1904, after the death of his son Lala Dharam Chand, Dayal closed the Bombay studio and one year later, the branch at Indore. Commissions and viceregal appointments still came to Dayal and to his remaining son, Raja Gyan Chand, at Secunderabad. From 1900 on, throughout the energetic viceregal tenure of Lord Curzon, Dayal accompanied the Viceroy on his annual autumnal tour of the native states. In 1903, the firm photographed the Great Delhi *Durbar*, where practically every native prince in India gathered to pledge fealty to the British Raj and its earthly representative, the Viceroy, Lord Curzon.

As a respected member of the Nizam's inner circle, Raja Lala Deen Dayal continued to photograph the grand hunts, princely tours, and the thrice-weekly *durbars*. In the houses granted to him by his patron there was a large and growing family of grandsons and granddaughters. In 1910, surrounded by the tangible artifacts of his success, Raja Musavir Jung Lala Deen Dayal died. Unfortunately for his heirs, his son and grandsons, their great patron—the man who more than any other had supported indigenous Indian photography—died just one year later. With the passing of Sir Mahbub Ali Khan, the sixth Nizam of Hyderabad, in 1911, the patronage that Dayal's family had so long enjoyed, ended.

The firm and Dayal's remaining son, Raja Gyan Chand, still enjoyed occasional commissions from the Viceroy. During the official visit of the first reigning British monarch to tour India (1911–12), Raja Gyan Chand dutifully followed George V, the King Emperor, on his travels throughout the subcontinent. But times had changed. The seventh Nizam succeeded to the throne at the age of twenty-six. Uninterested in photography, he withdrew the monthly stipend the firm had drawn for more than twenty-five years. In Hyderabad, a German named Frankel set up a rival photographic establishment and began to attract to his studio many of the *nawabs* and gentry, who were the last local patrons Raja Gyan Chand's firm enjoyed. Providentially, the First World War intervened, and in what amounted to a comic farce, Frankel was arrested as a German spy by the enthusiastic authorities of the state. He was interned for the duration of the war, but this merely deferred the decline in the Dayal family's fortunes.

When Raja Gyan Chand died in 1919, his sons, Trilok

Chand and Amichand, were too young to take an active part in the business. Throughout the 1920's, the firm carried on its business in a desultory way. Finally, in tragic decline, the family was obliged to sell the 40,000 to 60,000 glassplate negatives compiled by Raja Lala Deen Dayal—each carefully annotated and described—at the price that scrapped, used glass would bring in the local market.

In 1932, Amichand came of age and took over the affairs of the firm. He proved to be as effective and indefatigable as his grandfather in promoting the interests of the family business. The first step in repairing the fortunes of the firm was to regain the patronage of Sir Osman Ali Khan, the seventh Nizam of Hyderabad, and for five years, Amichand worked to rekindle the latter's interest. Finally, in 1937, after a hiatus of about twenty-five years, the family came once again under the patronage of the Nizam of Hyderabad. In revitalizing the family fortunes, Amichand sometimes worked eighteen hours a day in the darkroom, developing his grandfather's technique of being able to pose up to three hundred people on the 10″ x 12″ plate; three times a week he attended the Nizam's *durbars*. Because of his unique work (the court photographer had to constantly duck under his black cloth to study his negatives), Raja Amichand Lala Deen Dayal was granted the special dispensation of being allowed to appear at court in European clothes and without a hat—the only man at court permitted such a liberty. Gradually, over the next decade, the powers and privileges of Indian princes dimin-

ished and ultimately disappeared. On August 15, 1947, the British flag was hauled down for the last time in Delhi—an era had subsided into history.

Today, the family of Raja Lala Deen Dayal is still active in the fourth generation. There are several hundred commercial photographers in the city of Hyderabad; ten are considered the leading photographers, and of these, six are direct descendants of Dayal. A family tradition begun more than one hundred and three years ago, in 1875, continues today.

Oddly, despite the number of British Indian firms working in nineteenth-century India, only Raja Lala Deen Dayal received the ultimate patronage: "By Appointment, Photographer to Her Imperial Majesty, Queen Victoria." Artistic talent, technical skill, and a comfortable intimacy with Indian princes and British civil servants had enabled Dayal to gain the distinction of being the outstanding Indian photographer of the nineteenth century. But, for a fuller understanding of the significance of Dayal's work, a brief reprise of his career is necessary.

As a draftsman, documenting India's vast architectural treasures, Dayal trained his eye to capture the essence of Indian art. Later, as court photographer, his images became embodiments of an aesthetic tradition that had begun to decline rapidly with the advent of the camera. The preoccupations of the earlier Indian court painters had been intensely naturalistic, encompassing the vast and the minute, both rendered in closely observed detail. The classical Indian artist

*Told to author by a descendant; subsequently disputed by other family members.

was trained to move skillfully from subject to subject. Thus, Dayal, the photographer, turned from landscape to portrait to panoramic group shot to architecture to social commentary, with equal facility. The history of photography has produced few artists with such far-ranging capabilities and extraordinary scope.

As a complete *oeuvre*, Dayal's photographs have a significance on two distinct levels. At first glance, they comprise an astonishingly detailed history of an epic period in which two vastly different cultures had begun to interact. Their luxuriously incongruous meeting point is indelibly fixed for us in Dayal's images; no other nineteenth-century photographer documented as many diverse aspects of both Indian and British society on the subcontinent. Dayal's work reveals a veritable microcosm of the Anglo-Indian world at the high point of the British Raj.

On a more subjective level, the significance of Dayal's *oeuvre* lies in the aesthetic elegance of his images, all of which were carefully planned and composed, though the ultimate effect is deceptively natural. They are quite unlike many contemporary photographs in which the photographer finds a scene instead of arranging one. Today, technical advances in film and equipment have unlocked the multiple possibilities inherent in the candid photograph. During Dayal's time, however, a staggering amount of preparation went into picture making and picture taking.

In his photograph of the deformed Maharaja of Dhar, the prince holds a kohl-eyed child (p. 35). The picture, posed in the aseptic surroundings of the photographer's studio, shows considerable attention to detail. While the character of the Maharaja seems youthful and ageless, the child, with her great black-rimmed eyes, seems solemn, aged, almost a personification of the goddess Kali, the goddess of destruction. On another level, at first glance the child seems huge, the adult minute. An ordinary photographer might have posed the Maharaja seated with the child on his lap. But Dayal posed the subject standing to accentuate his deformity, thereby creating the visual paradox of an ageless dwarf holding an aged child.

Similarly, in his photograph of a British lady on horseback (p. 81) Dayal chose to heighten and accentuate relationships between the subjects shown. The woman is seen formally posed astride her horse, her gaze properly aloof, disdainful, and yet compelling. Standing to her side in respectful obeisance is her servant and in the background is her husband, accompanied by her dog, staring wistfully at her through the window. The figures are positioned in such a way as to form an artistically elegant frame and to offer an incisive comment on their interpersonal relationships. On two different levels, in two separate cultures, the photograph is a penetrating vision of ruler and ruled.

In Dayal's picture of the British baggage train at Jhansi Fort (pp. 62-63) we see the matured vision of the Indian artist. Consider the elements: several hundred bullocks yoked

together with at least twenty elephants, posed in front of the dilapidated ruins of a seventeenth-century fort in Central India. Dayal surmounts the staggering difficulties of arranging the moving parts of this image, freezing them for the requisite two-to-five-second exposure, balancing the massive bulk so as not to overshadow the background—all culminating in a photograph as beautifully composed as a still life. Indeed, there is this quality to all of Dayal's large group photographs, the same exquisite balance that one might expect to find on a canvas but that is so much more elusive on a photographer's plate. The immediacy of this photograph makes it appear casual, yet simply to orchestrate this picture, let alone reconcile its various elements into a finished photograph, was a tour de force.

The dual importance of the work of Raja Lala Deen Dayal lies in its presentation of an Indian view of life under the Raj and in its preservation of the traditions of classical Indian art. In replacing the court painter, Dayal assumed all the functions attendant upon that role. Where the painter had preserved on paper the style and splendor of earlier Mogul courts, Dayal, with his camera, created a mythic museum of courtly life during the nineteenth and early twentieth centuries. Ultimately, these photographs transcend the level of purely documentary interest. As a photographer who prized the heritage of his native art, Raja Lala Deen Dayal was able to filter through his lens a view of the world that was uniquely Eastern and permeated by the traditions of classical India.

Glossary

Dewan	— The chief financial officer or the Prime Minister of a native Muslim state.
Durbar	— A court or levee. Though used in the Mogul period, the term "durbar" came to represent the epitome of the Anglo-Indian (and viceregal) occasion of state. Attendant upon a grand *durbar*, taxes were remitted and prisoners freed in a general amnesty, but more important, the relationship of the native princes to the paramount chief (the King of England) was reaffirmed.
Ghazal	— A short lyric in which the theme of love predominates. Generally composed of five couplets, a *ghazal* is ideally "a conversation between lovers."
Mahout	— The driver or tender of an elephant.
Nawab	— A Muslim ruler. Also a title conferred by the British on a Muslim of rank and distinction. See *Raja*.
Purdah	— Literally, a curtain or screen used in India to seclude women. The word is an anglicized version of *pardah*, a Hindi and Persian term for "veil." See *Zenana*.
Raja	— A petty chief or large landowner. Later, also, a title of nobility conferred during the Victorian period by the British Government on Hindus. See *Nawab*.
Taalukadar	— The holder of a local estate.
Tahsildar	— The chief revenue officer of a subdivision.
Zenana	— The apartments of an Indian house in which the women of the family are secluded. Originally a Muslim custom, by the latter half of the nineteenth century it had become an almost universal practice of traditional elements in both the Hindu and Muslim communities of northern India. The word "zenana" is Hindi, taken from Persian. See *Purdah*.

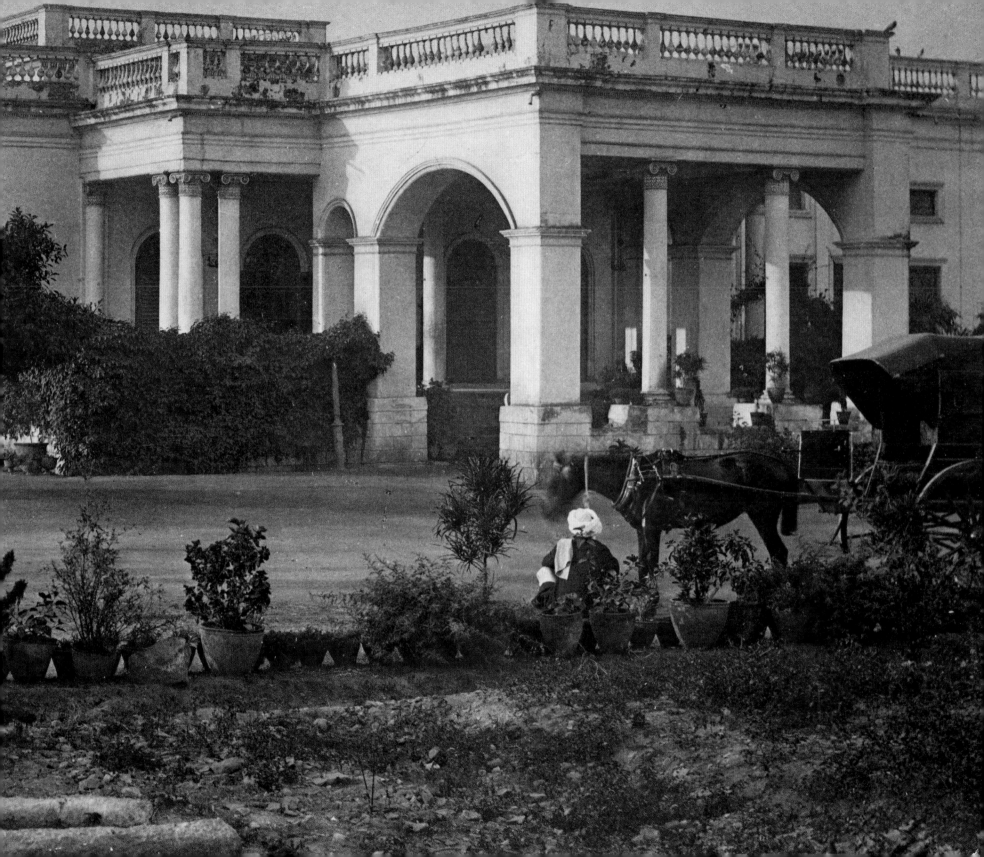

Sir Mahbub Ali Khan's three palaces, like his courts, were constructed of stone and marble, but became the stuff of legend. Of the three, the Falaknuma best illustrates the tastes and surroundings of the princes of India. Oddly, though, it was built not for Mahbub Ali Khan, but for one of his Prime Ministers, Sir Vicar ul Umra. A perfect mirror for the Nizam's vision of elegance, the palace had been acquired by him in the following convoluted way.

A man of lavish appetites, Sir Vicar had overextended himself in building the Falaknuma. In assembling his palace he insisted on only the most costly ingredients money could buy. The marble in the foyer came from Italy, and workmen appeared from Florence to install a tooled-leather ceiling in the great banquet hall after Indian artisans had completed the shell of the building. In France, an entire nunnery was engaged to work on a special camel-hide upholstery for chairs that were meant to match the ceiling of the banquet hall. Furniture was assembled from all the great shops of Europe, and French brocades arrived to cover the Empire-style chairs and sofas. In London, St. James was emptied to provide crystal stemware, crested silver and gold services. (The ornate work of the jeweler Fabergé was rejected as too gaudy.) When the palace was finished, crates of Victorian bric-a-brac arrived in Hyderabad to cover every available empty horizontal surface in the Falaknuma.

Of course the Prime Minister was virtually a bankrupt man when he added up the cost of his grand vision. And so he would have remained had not one of Sir Vicar's ladies suggested that he invite the Nizam to be a guest in the new palace. When the Nizam arrived, he stayed a week, ten days, two weeks, three weeks, until he decided he could not live anywhere else and bearded his Prime Minister with this declaration. Sir Vicar was reported to have drawn a long, quiet breath before replying, "Sire, I built it for you." The next day three generations of the Prime Minister's family moved out of the palace, displaced perhaps, but once again financially solvent.

Adapted from *The Days of the Beloved*
by Harriet Ronken Lynton and Mohini Rajan

Preceding Pages The Khana Bagh Palace of Nawab Asman Jah, Hyderabad, 1890.

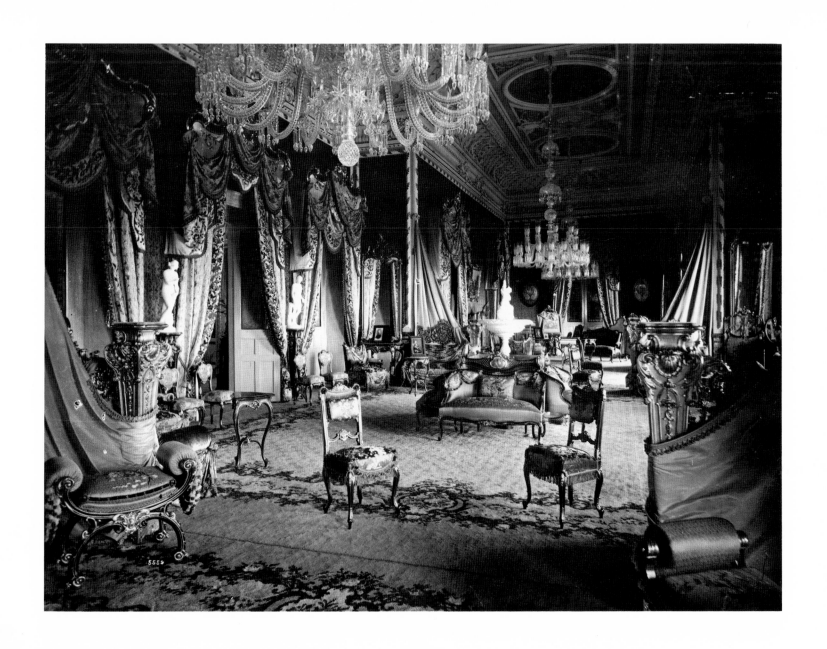

Interior of the Falaknuma Palace, Hyderabad, 1890's.

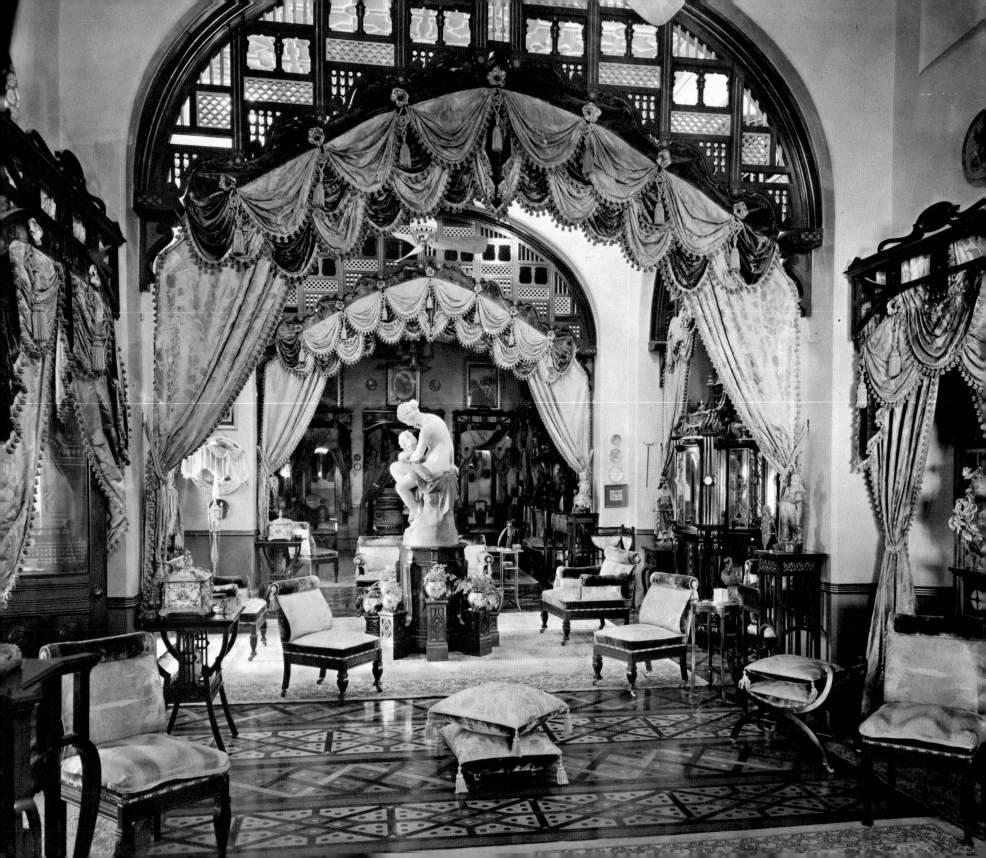

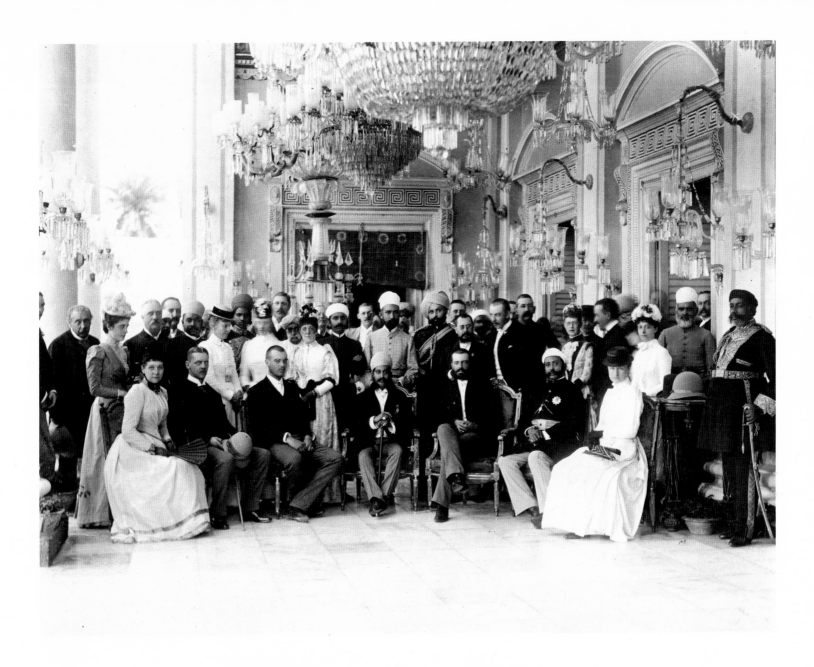

Group portrait with H.H. the Nizam and H.I.H. the Grand Duke Alexander of Russia (at Nizam's left), the Chowmahalla Palace, Hyderabad, March 11, 1891.

Opposite H.H. the Nizam's drawing room, where he received important visitors, 1888.

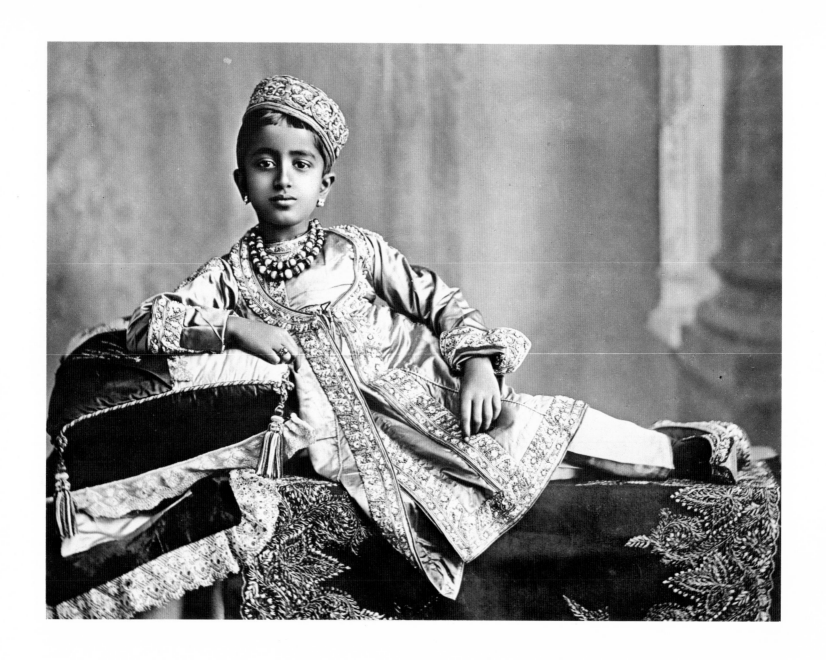

Fateh Singh Rao, the eldest son of the Gaekwar of Baroda, 1891.

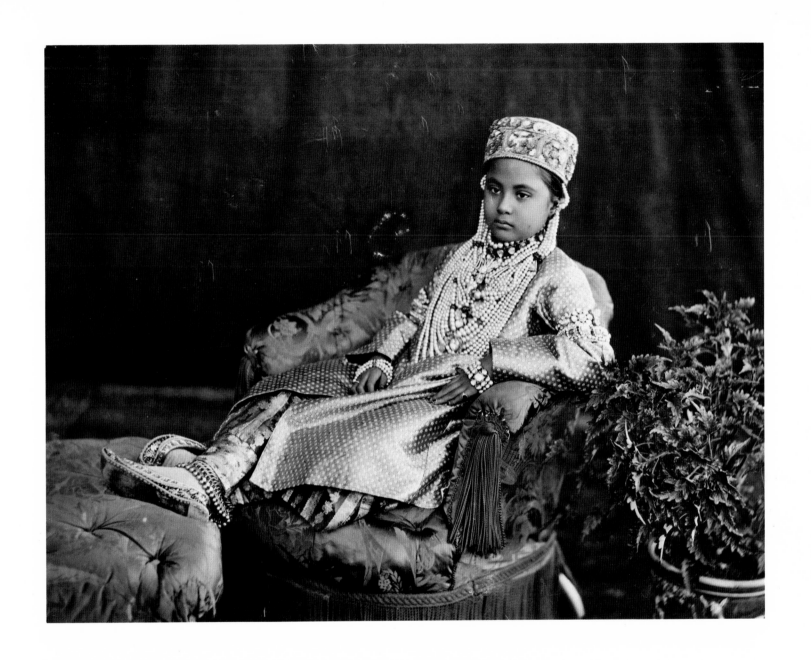

H.H. the Nizam's daughter, 1890's.

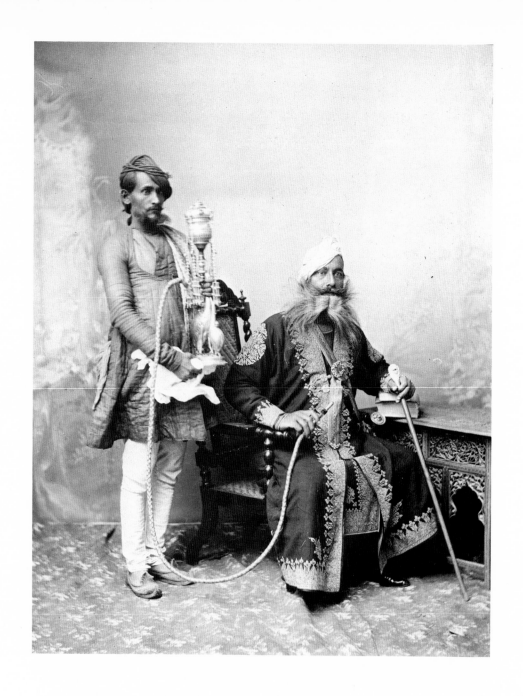

The Maharaja of Orcha, Sir Pratap Singh, with water-pipe bearer, 1890.

Opposite View of the interior of a Jain temple, Mt. Abu, Rajputana, 1880's.

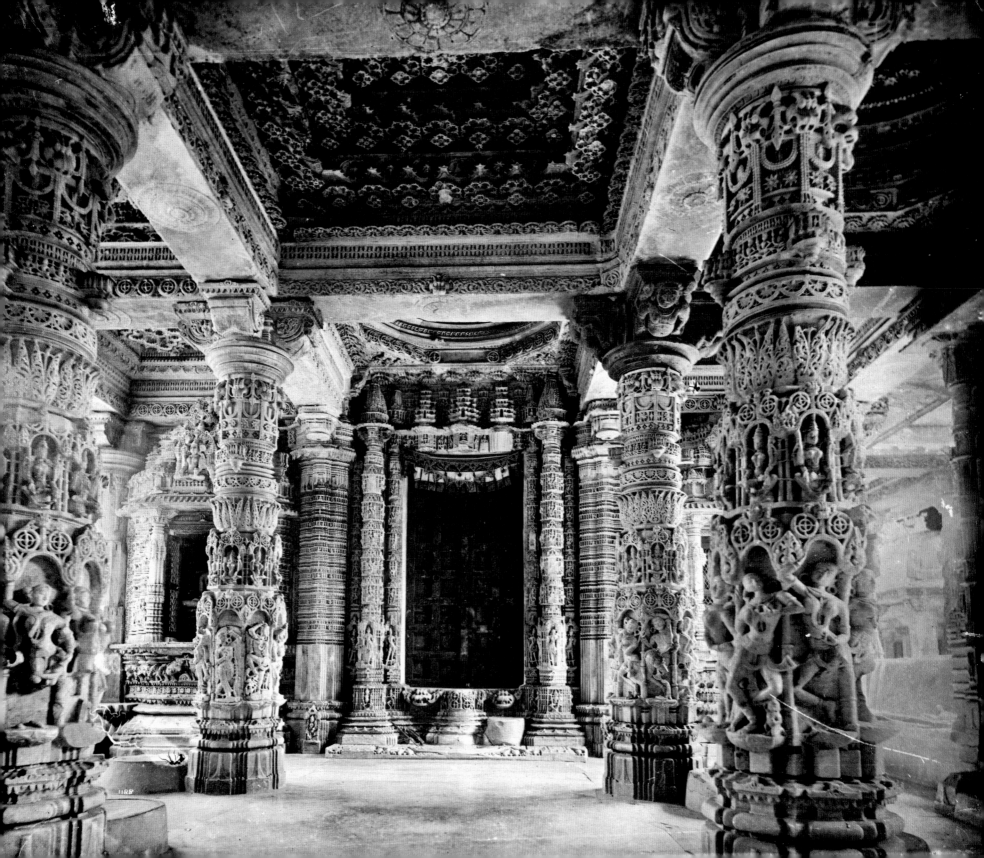

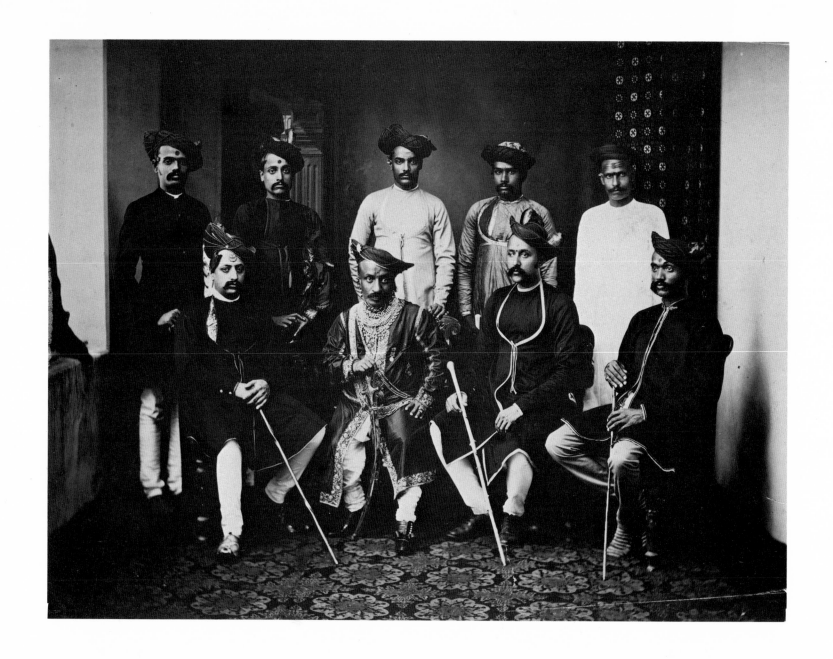

The Maharaja of Dhar and suite, 1884.

Opposite The Maharaja of Dhar, Anand Rao Pawar, 1884.

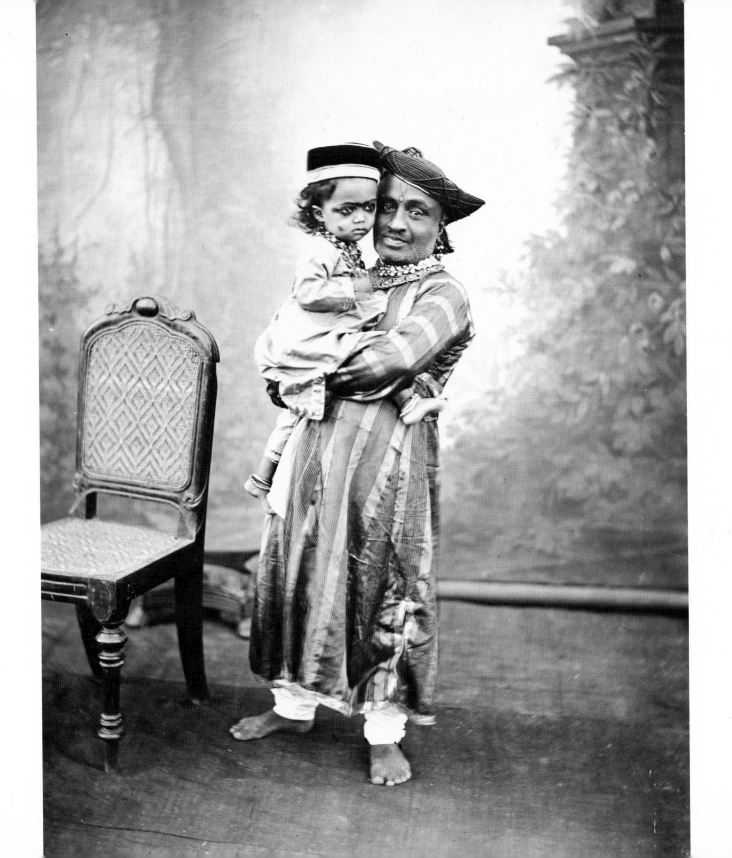

35

Increasingly, the eccentricities of maharajas came to be the fodder for decades of newspaper gossip columns, both in India and abroad. One maharaja bought two hundred and seventy automobiles; another bought a hardware warehouse in England on the imagined slight of its British proprietor and had the entire contents of the establishment gift-wrapped and sent to India. Still another maharaja in Central India refused to let the British Government build a railway across his territory because, as a devout Hindu, he was appalled by the possibility of passengers devouring beef inside dining cars as they clattered across the realm. And another, a lover of Scotland, bought complete Highland uniforms for his household troops, perfect in every detail from kilt to feathered bonnet, but added pink tights to the ensemble to give dusky knees a verisimilitude to Scotsmen's weathered ones. Still another of the Indian princes took it upon himself to protect a visiting English duchess on a nocturnal tiger hunt by thoughtfully equipping an elephant not only with a searchlight but with a light machine gun as well. One maharaja prided himself on his state golf course tended by hundreds of convicts, while another, unfortunate in love, checked into his favorite Parisian hotel suite, ordered up a stock of the most expensive champagne, then premeditatedly drank himself to death inside two short, bubbly weeks. The Maharaja of Patiala, who regularly occupied thirty-five suites (the whole fifth floor) of the Savoy on his visits to London, had members of his bodyguard sleeping across the thresholds of his rooms and kept twenty chauffeurs on retainer to be available at a moment's notice. Daily, three thousand fresh roses were brought to the prince to satisfy his love of nature.

Adapted from *The Maharajas*,
by John Lord

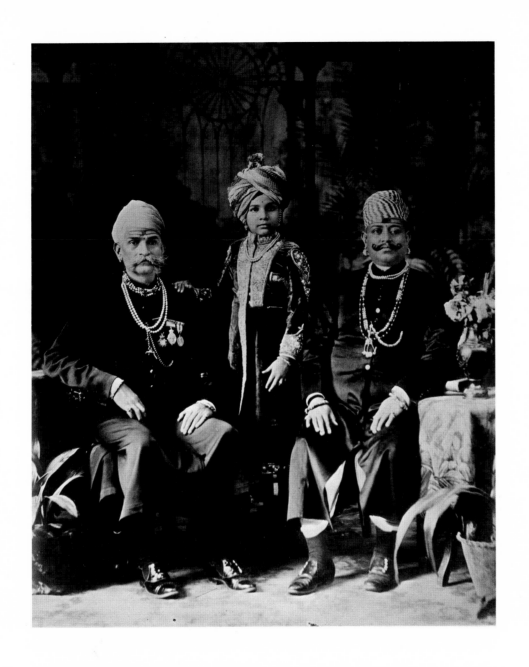

The Maharaja of Bikaner (center), with members of his Regency Council, 1891.

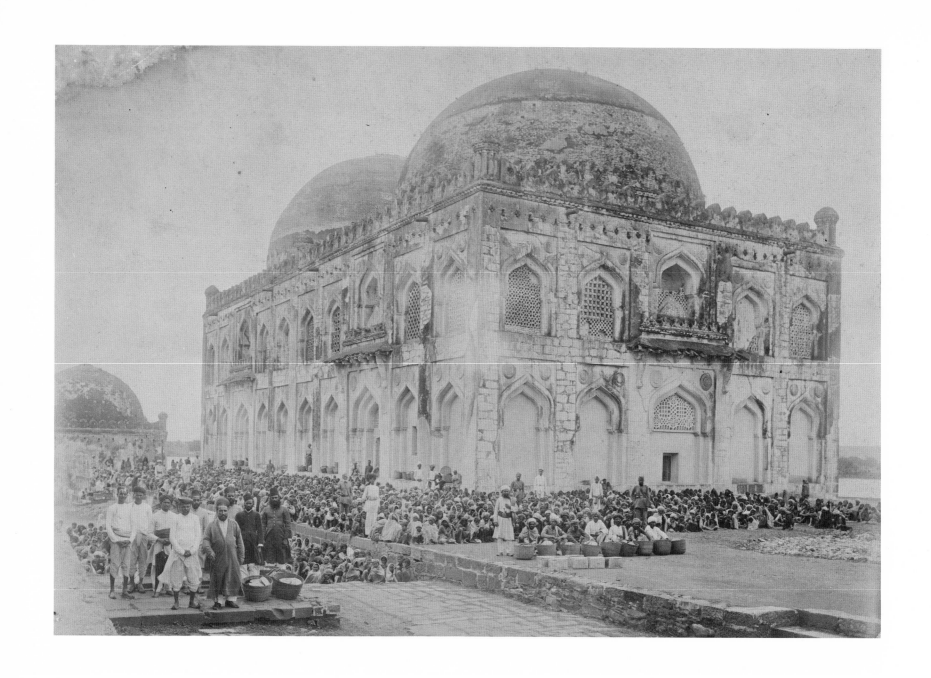

Tomb, Bijapur, 1900.

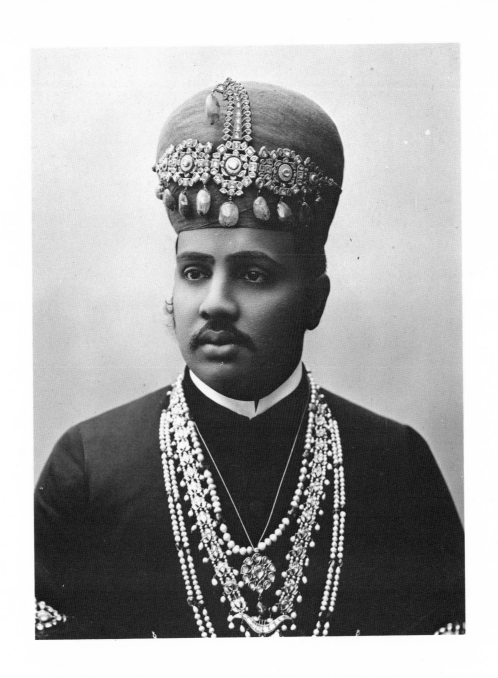

Prince, Hyderabad.

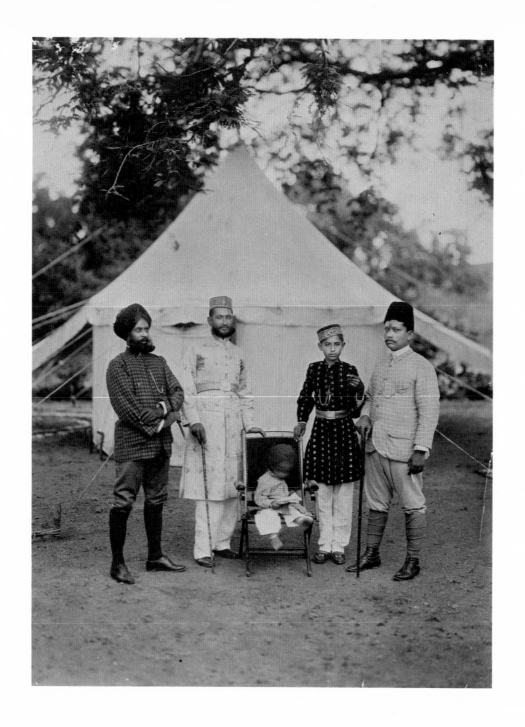

Group of four state officers and child prince, Kalamnuri, September 23, 1900.

Opposite Local nobles, with attendants, 1880's.

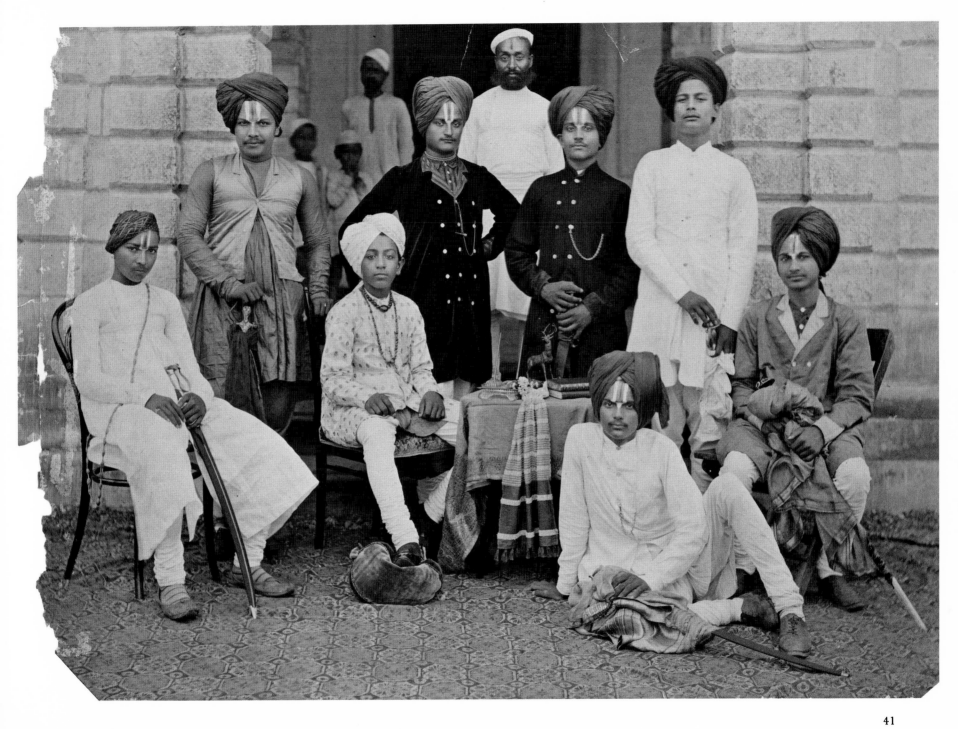

41

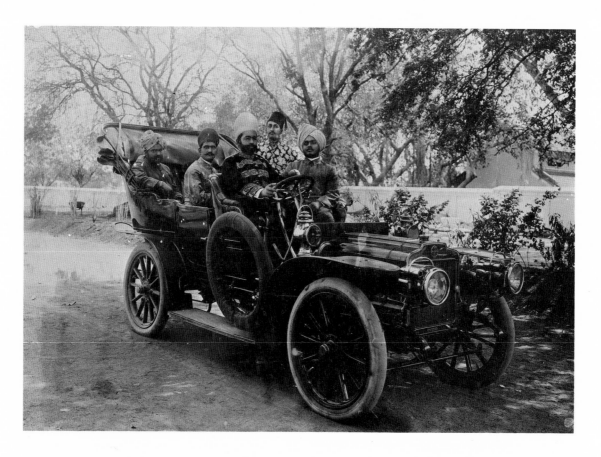

In 1908-9, motoring had come into favor in India, and the Nizam of Hyderabad had a fleet of some thirty cars. The head chauffeur was an Englishman and an expert driver. To please his master's desire for rapid movement, he now and then outrageously exceeded all speed limits, not realizing how Orientals prefer to walk in the middle of the road and how slow they are to move out of it. An old Indian woman was run over and killed one day by the Nizam's car. His Highness was much distressed and sent a generous gift to the family.

Thereafter, British observers noted that whenever the Nizam went motoring, there was much difficulty in clearing the road of the aged poor, who had been deliberately put in the way by their impecunious relatives.

Adapted from *India As I Knew It*,
by Sir Michael O'Dwyer

Above Hakim Abdul Razaak (at steering wheel), physician to H.H. the Nizam, with group in motorcar, 1908.

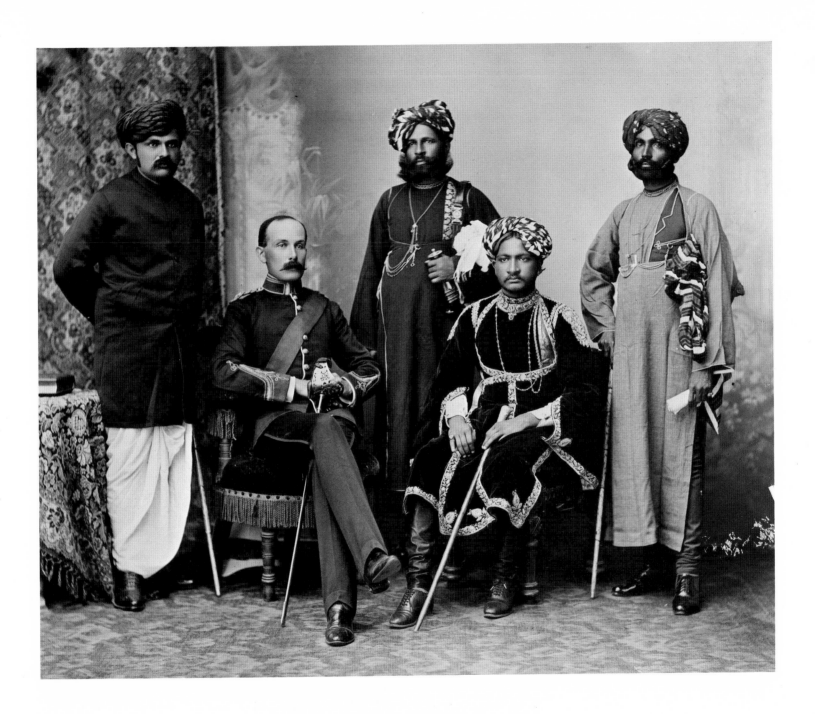

Noblemen of Hyderabad, with British officer, 1893.

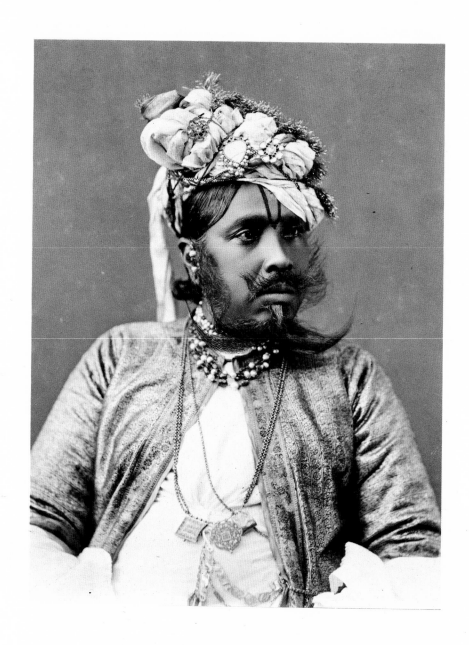

Prince, 1888.

Opposite H.H. the Nizam's daughter, dressed in rubies and pearls, 1890's.

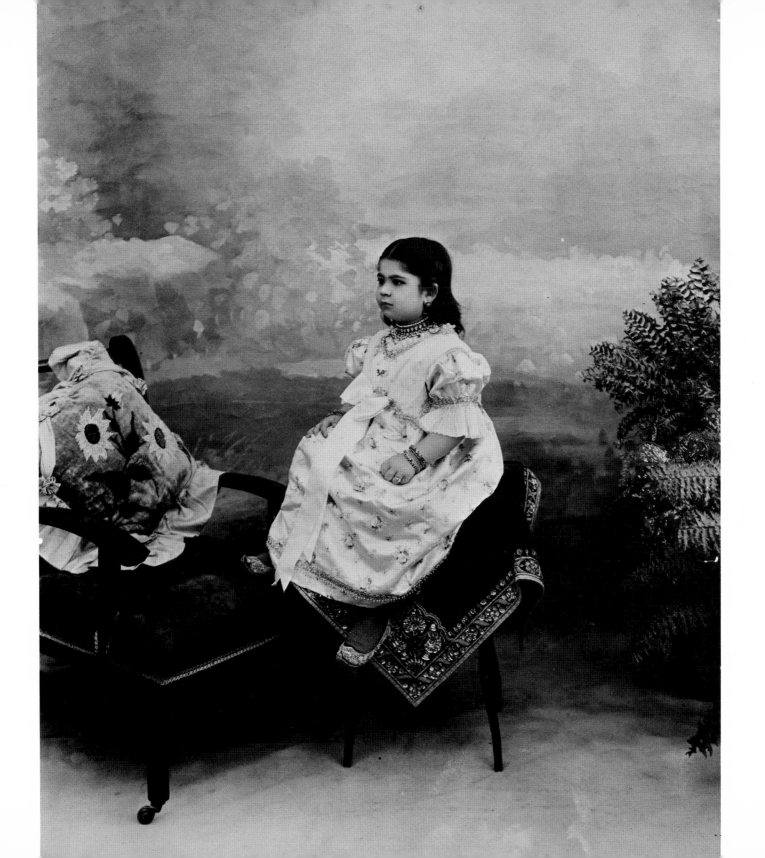

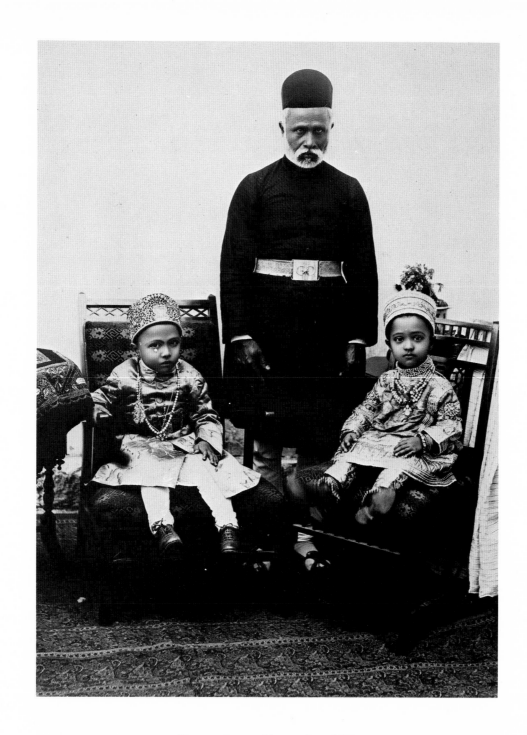

Young princes, with attendant, 1900.

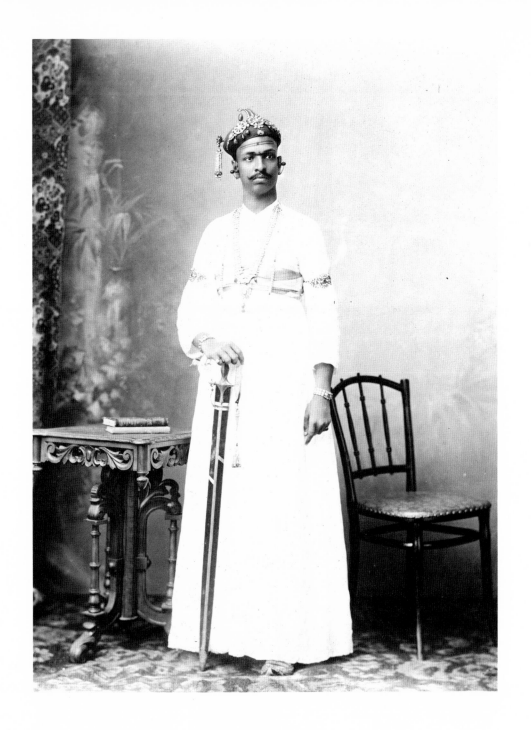

Prince, Hyderabad, 1900.

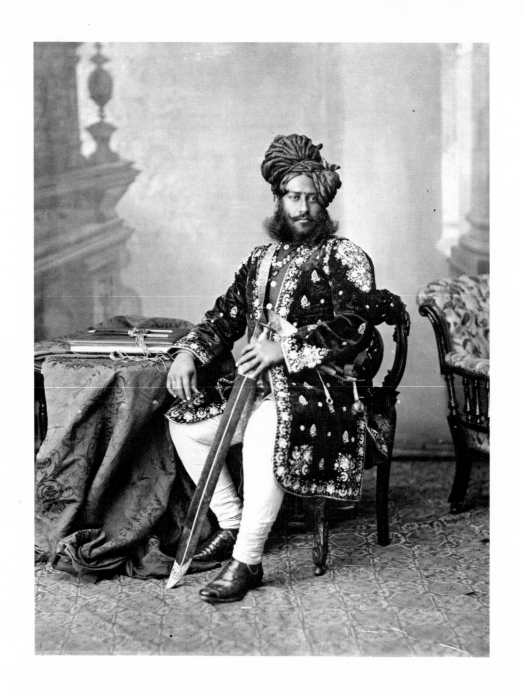

Prince, 1888.

Opposite Sir Jayaji Rao Sindhia, Maharaja of Gwalior, with attendants, 1882.

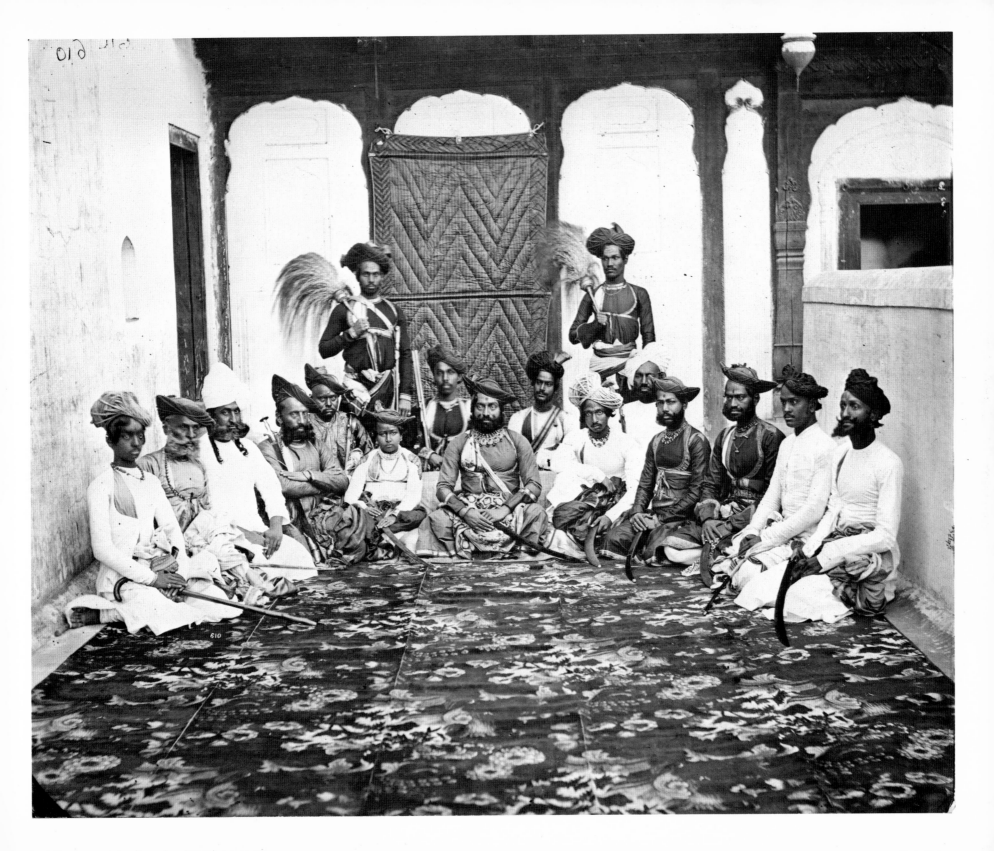

Sir Mahbub Ali Khan, the sixth Nizam of Hyderabad, began the tradition—later taken up by many of the princes—of sending his laundry out to be done. "Out" in the Nizam's case did not mean Central India, however. For decades, Ali Khan had all his dirty clothing shipped via the Peninsular & Oriental steamship line to be laundered in Paris.

No one will ever know the full extent of the sixth Nizam's lavish spending. A single example will suffice. A representative of an old and distinguished firm of British tailors came to Hyderabad to measure the Nizam for a few new Western-style suits. Taken by a particular Scottish tweed, Mahbub Ali Khan's enthusiasm knew practically no limit. To ensure that no one would turn up anywhere looking precisely like him, he ordered all five years' production of this particular tweed bought up from the looms along with the patterns to make the tweed. In time, this purchase resulted in hundreds of identical suits, complete with accessories, which continued to arrive years afterwards, by which time the Nizam had lost interest.

Adapted from *The Days of The Beloved,*
by Harriet Ronken Lynton and Mohini Rajan

H.H. the Nizam (seated, without hat) and staff, at tea party on *shikar* (hunt) near Warangal, May 1892.

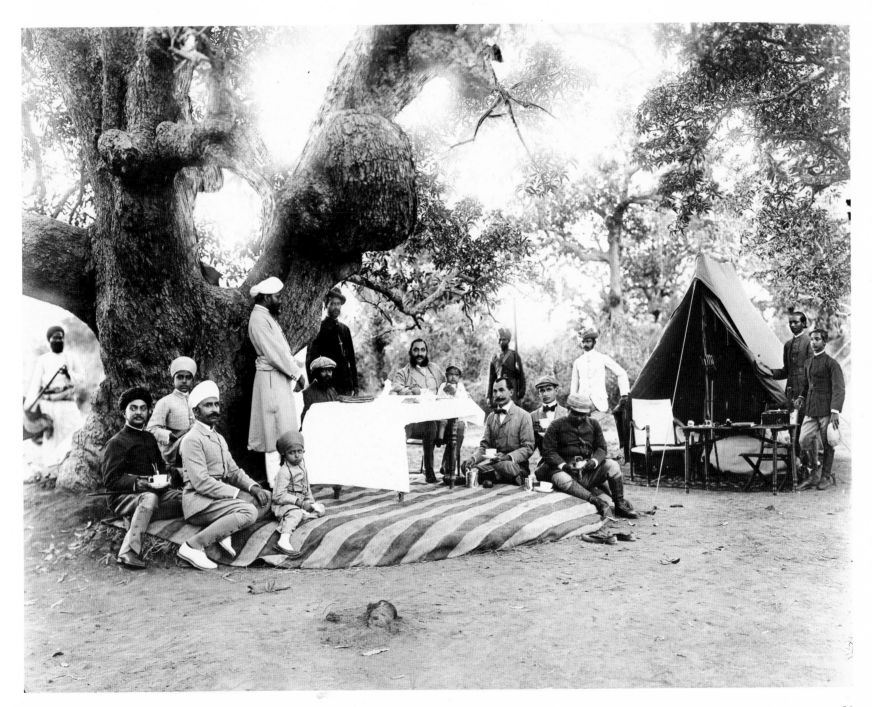

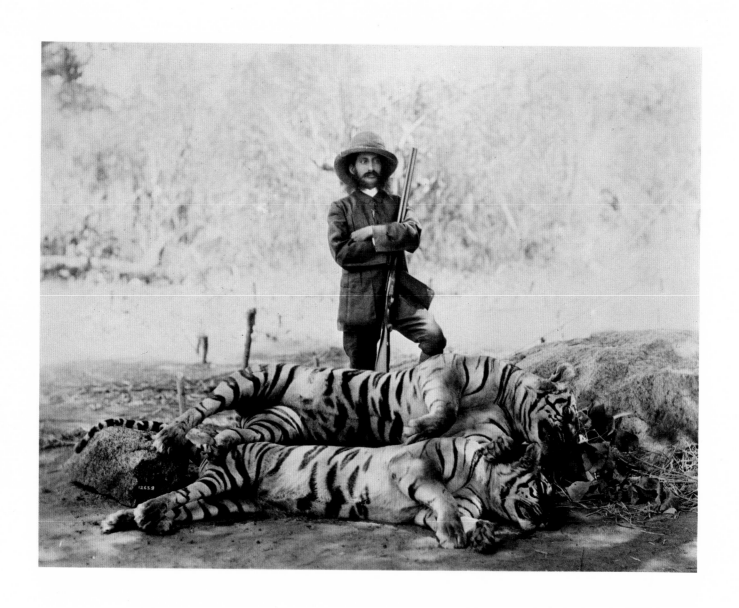

H.H. the Nizam, with the day's bag, Nekonda, 1894.

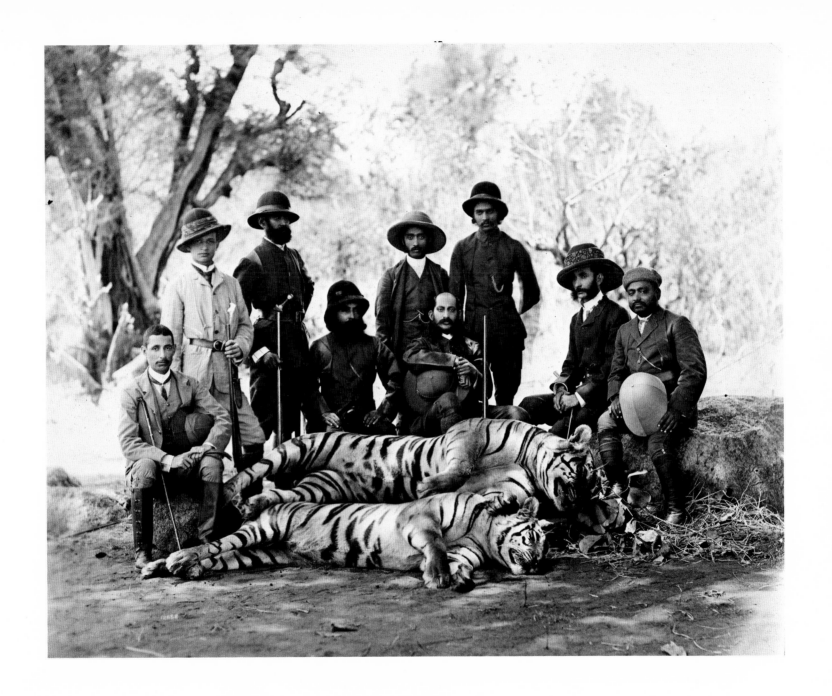

H.H. the Nizam, Madanpalli, 1892.

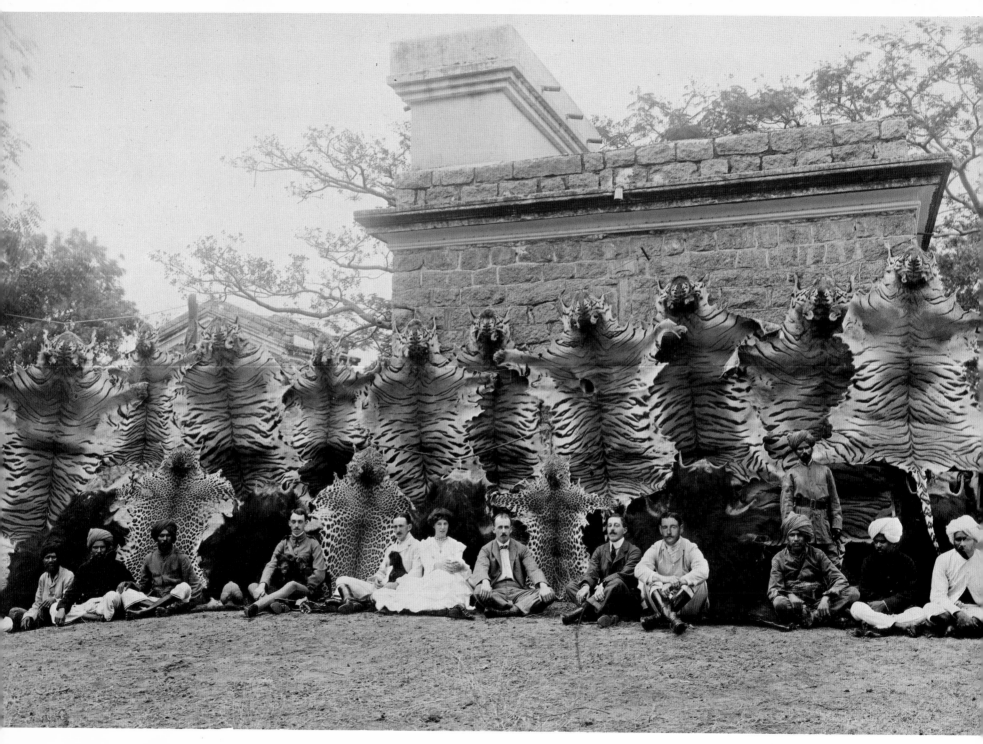

54

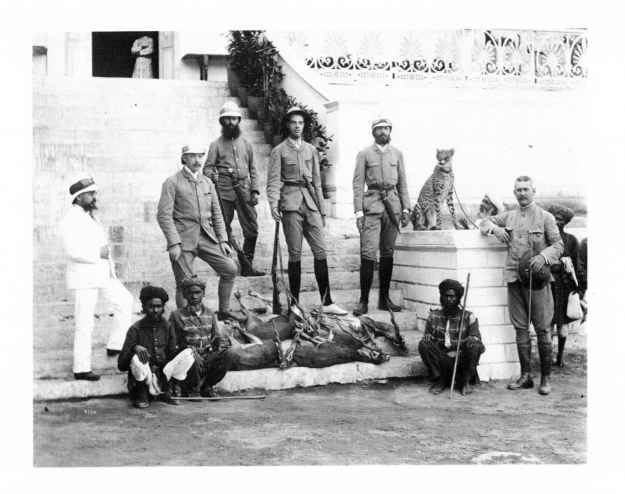

Hunting party. H.I.H. the Grand Duke Alexander of Russia on the steps (right) of
the Falaknuma Palace, Hyderabad, March 11, 1891.

Opposite Hunting party, 1900's.

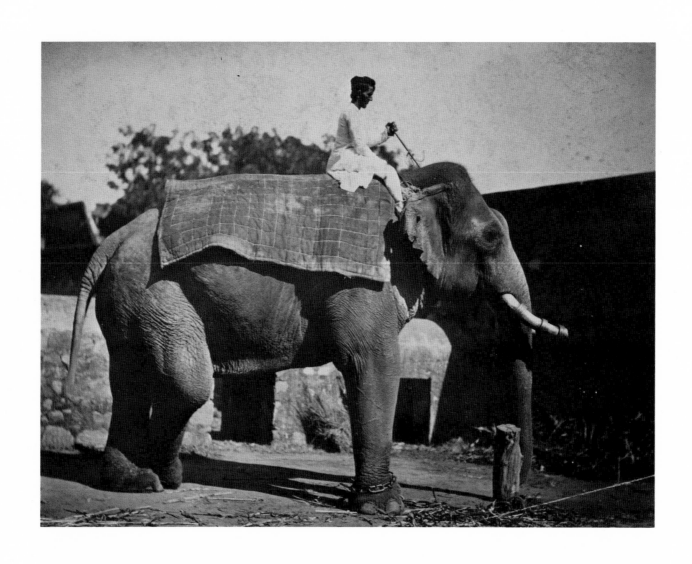

Elephant with *mahout*, 1888.

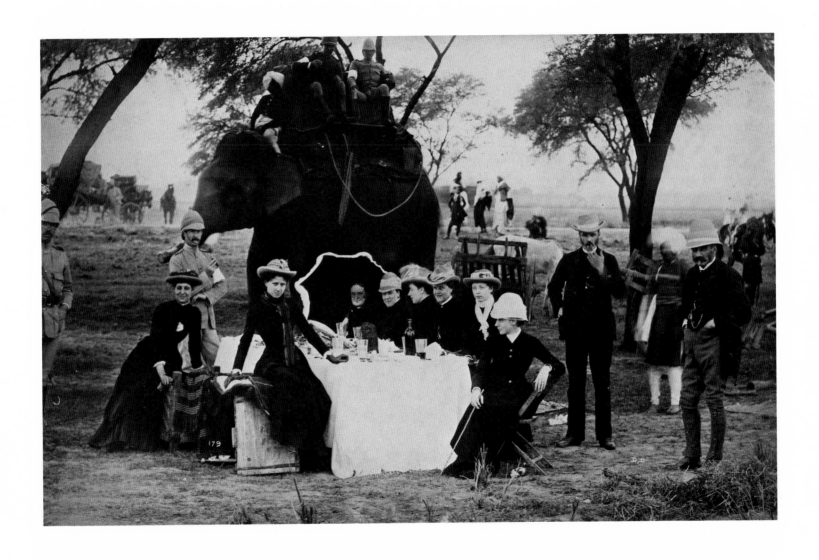

The Commander-in-Chief Lieutenant-General Frederick Roberts' luncheon party,
the Panipat Maneuvers, 1886. These maneuvers, held on the battlefield at Panipat
(outside Delhi), were designed to test the Indian army's readiness for war at the
moment of the annexation of Burma.

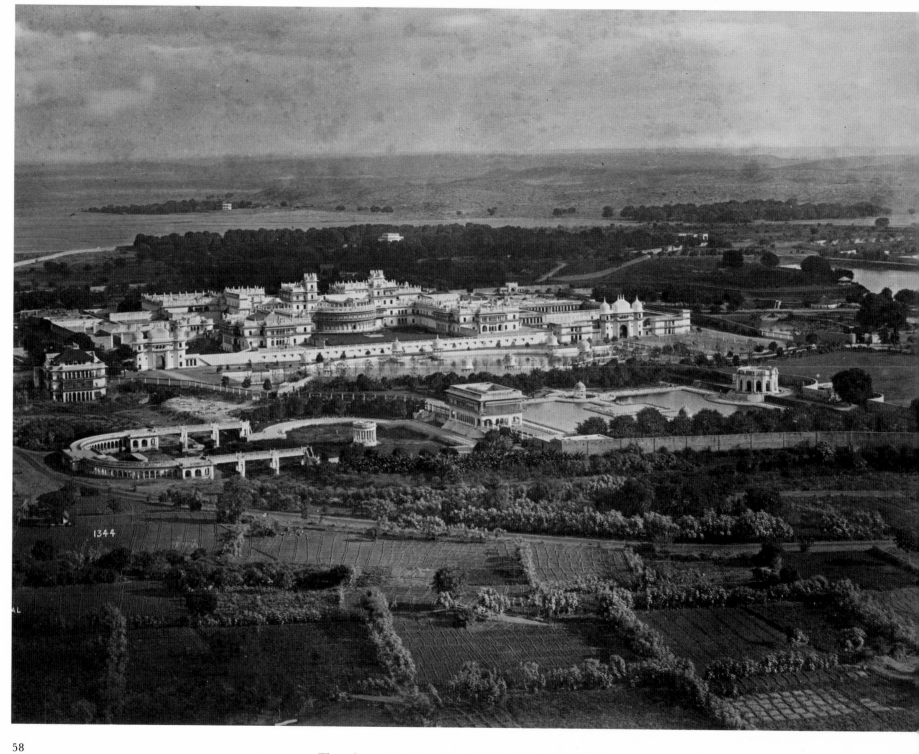

The palaces at Gwalior, Central India, 1882. Gwalior was noteworthy for housing the largest crystal

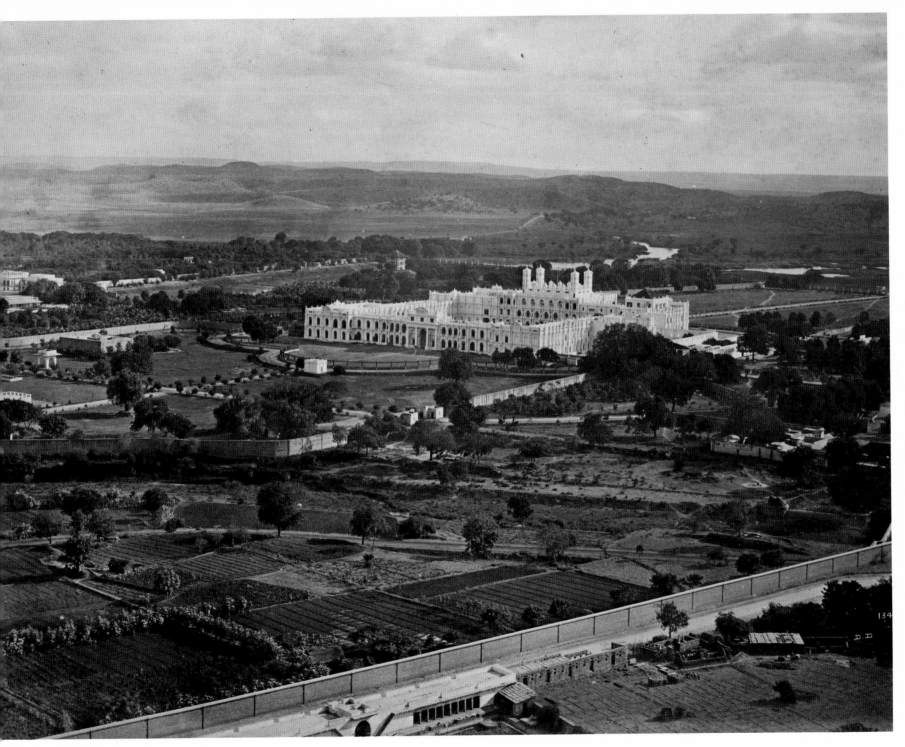

134

59

chandelier in Asia, as well as an elaborate electric train mounted on the main banquet table, which transported food to the guests.

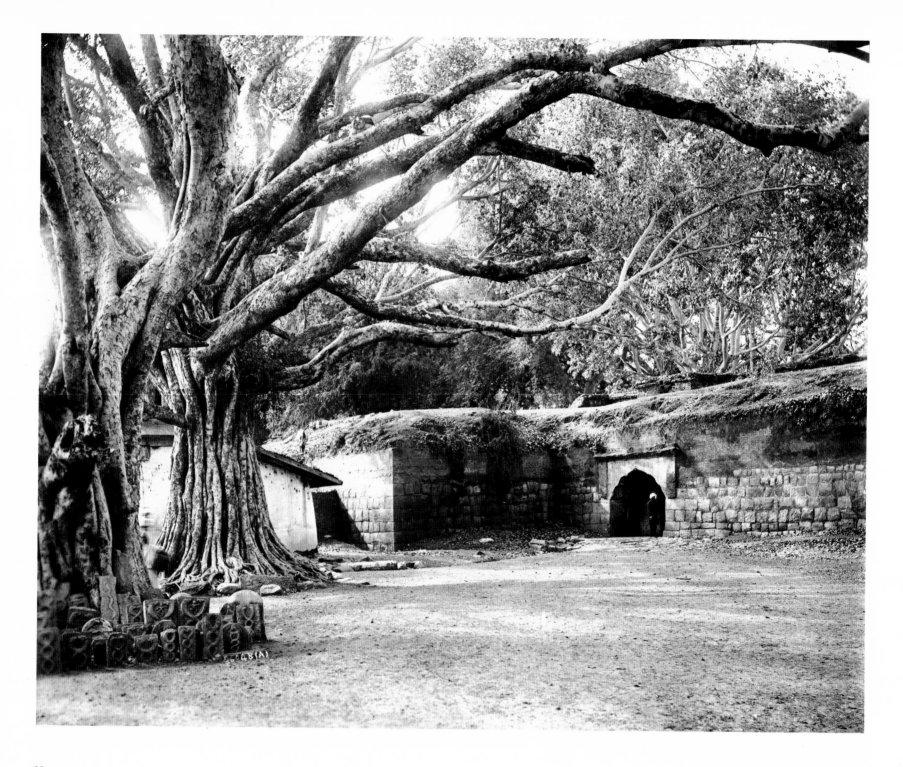

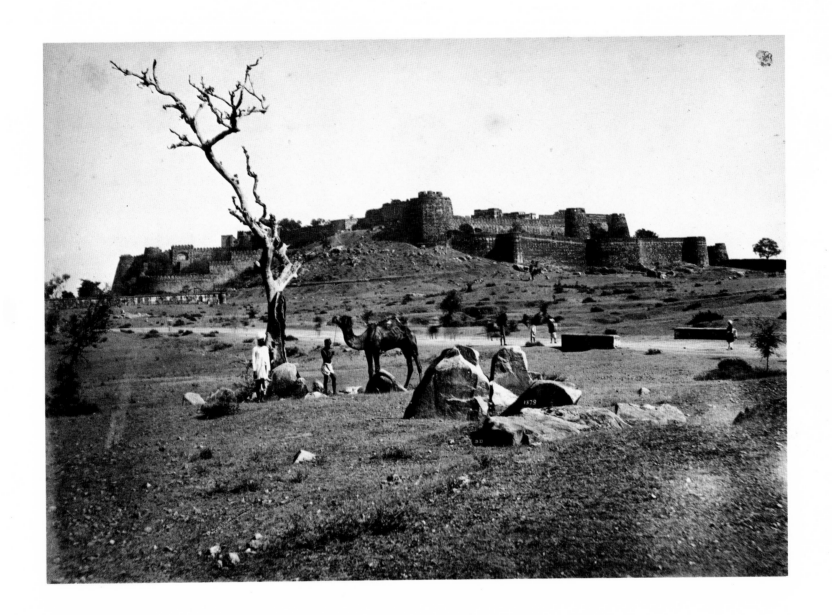

Jhansi Fort, 1882.

Opposite Sally Port Gate, Seringapatam, 1884. On this spot, Tipu Sabib, Sultan of Mysore, the last Muslim ruler to challenge British power in India, was killed in the battle of Seringapatam on May 4, 1799. Commanding the British reserve force was Colonel Arthur Wellesley, who later was created Duke of Wellington.

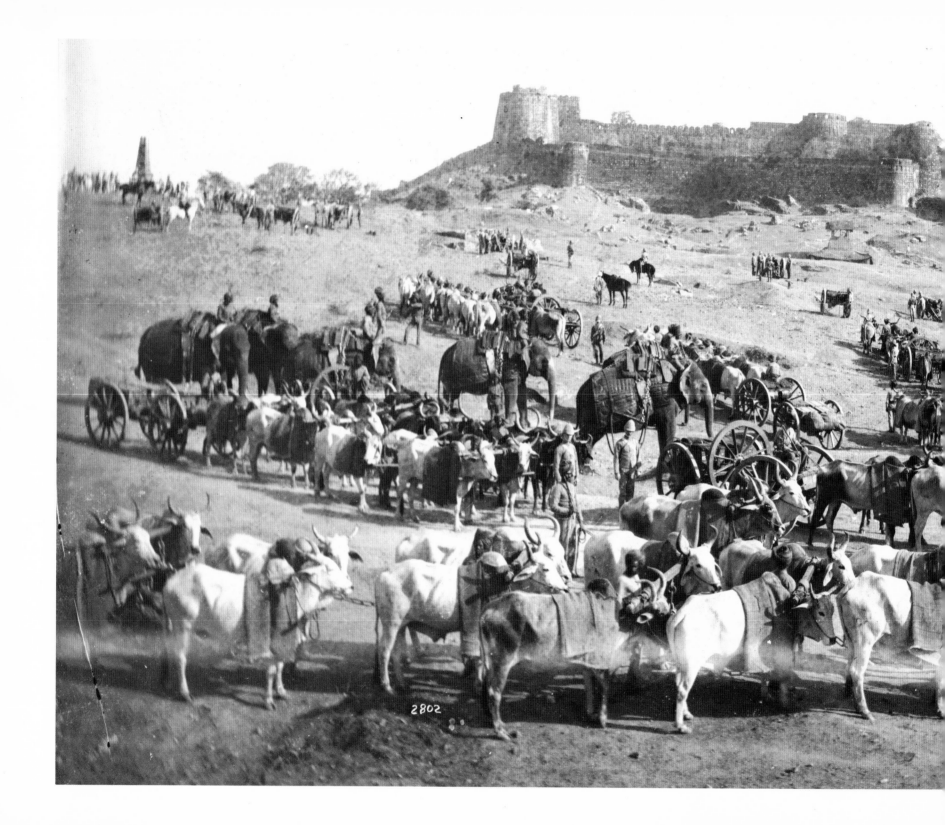

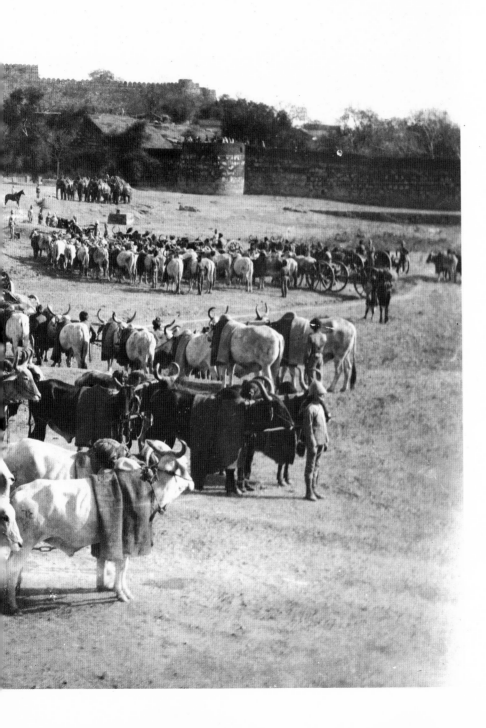

British baggage train, Jhansi Fort, 1882.

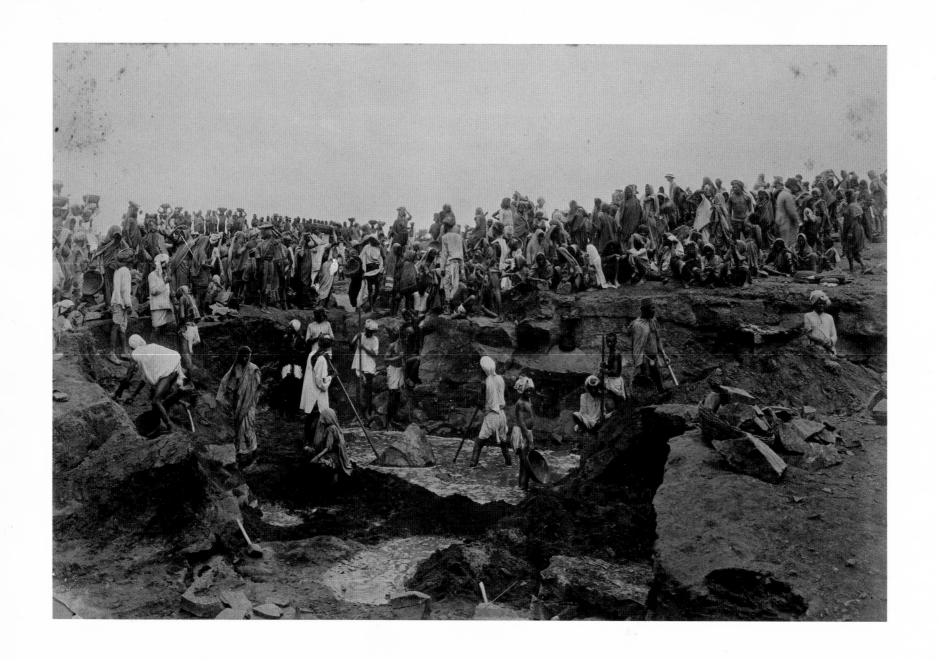

Famine relief work, the Nizam's dominions, 1900.
During a time of famine, local governments would undertake extensive public
works projects in order to feed victims of drought.

I now come to the government of the mines [at Golconda]. Business is conducted with freedom and fidelity. Two percent on all purchases is paid to the king, who receives also a royalty from the merchants for permission to mine. These merchants, having prospected with the aid of the miners, who know the spots where diamonds are to be found, take an area about two hundred paces in circumference...these poor people [the miners] earn only about three pagodas per annum [three pence a year], although they must thoroughly understand their work. As their wages are so small they do not manifest any scruple...concealing a stone when they can, and being naked, save for a loin cloth which covers their private parts, they adroitly contrive to swallow it....In order to prevent these knavish tricks each merchant always employs ten or twelve watchmen to see that they are not defrauded.

From *Travels in India*, by
Jean-Baptiste Tavernier, Baron of Aubonne

Above Diamond fields (panel of a three-plate panorama), Partial, 1885.

Overleaf "The Retreat," Panipat Maneuvers, 1886.

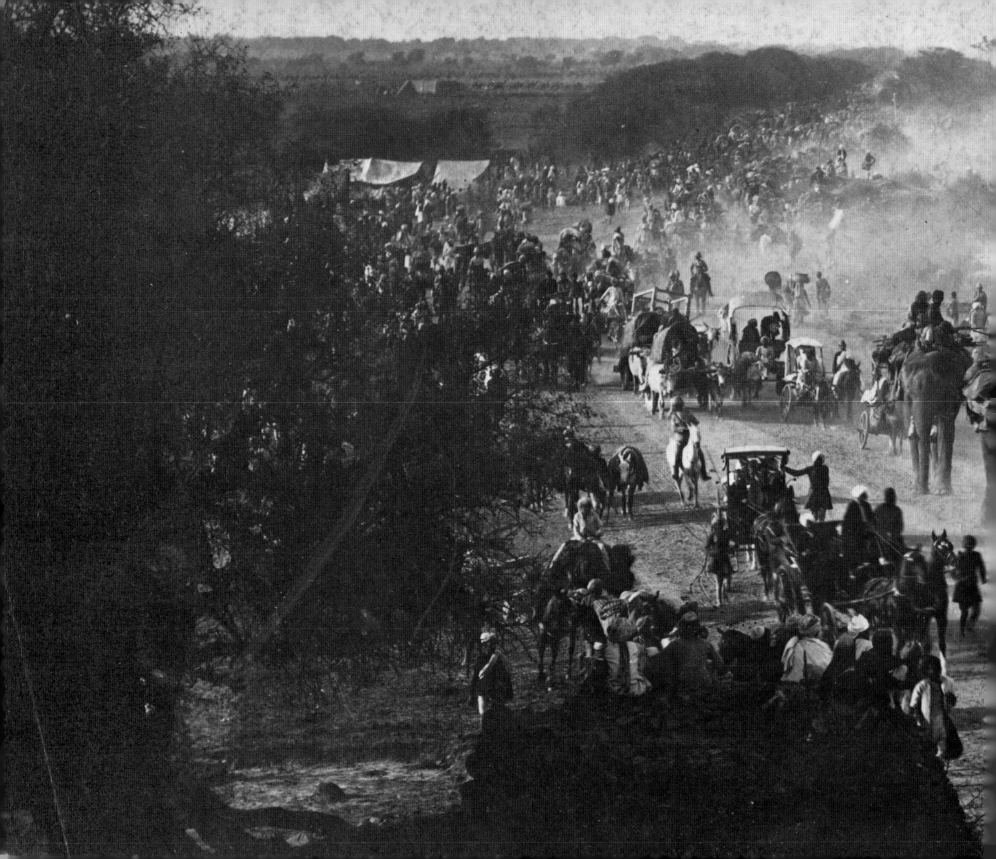

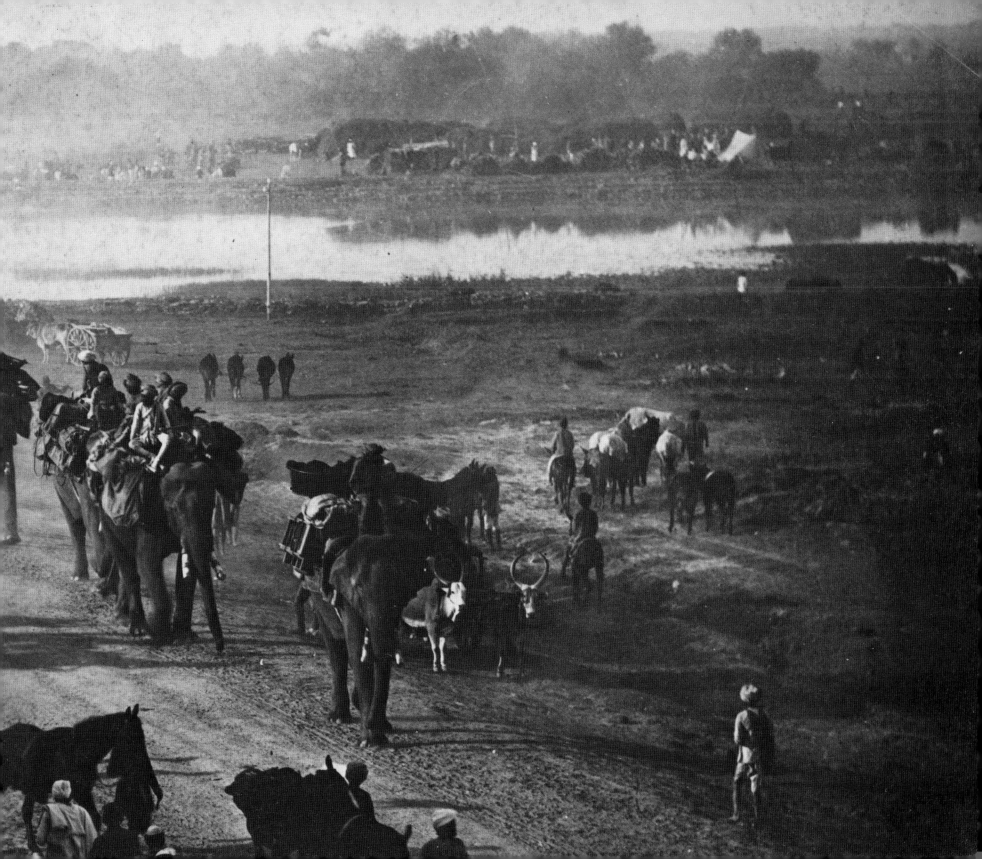

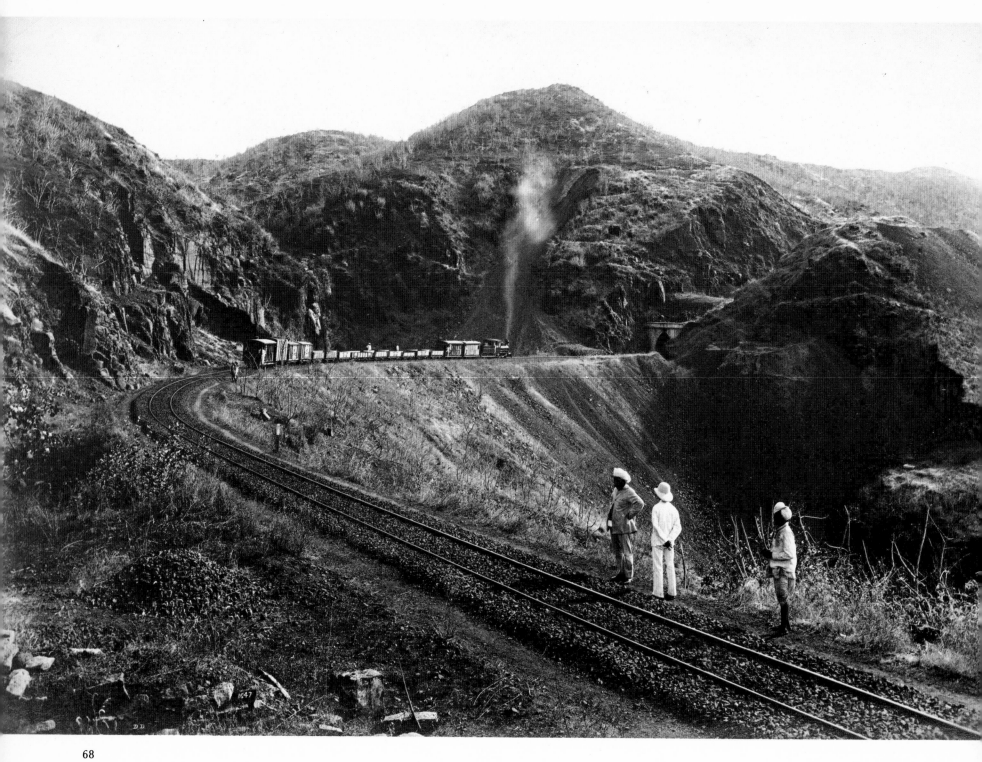

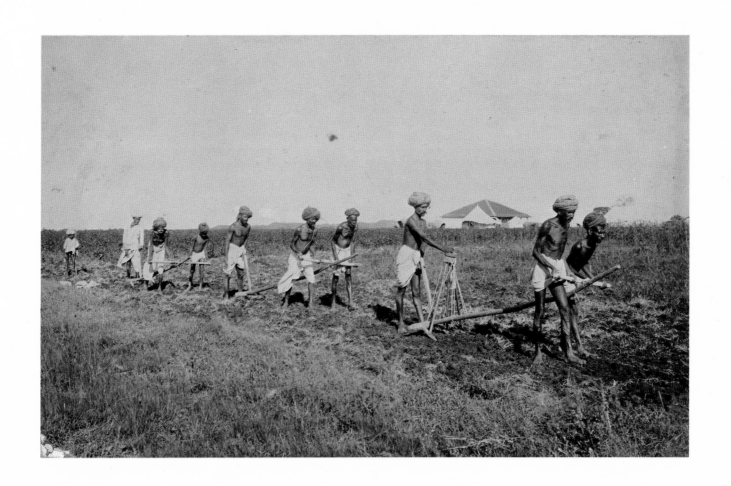

Famine relief work, the Nizam's dominions, 1900.

Opposite Tunnel No. 2, the Indore State Railway, 1878.

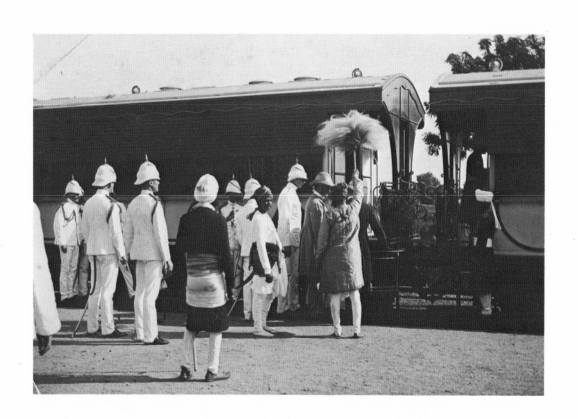

British official boarding train, 1900-10.

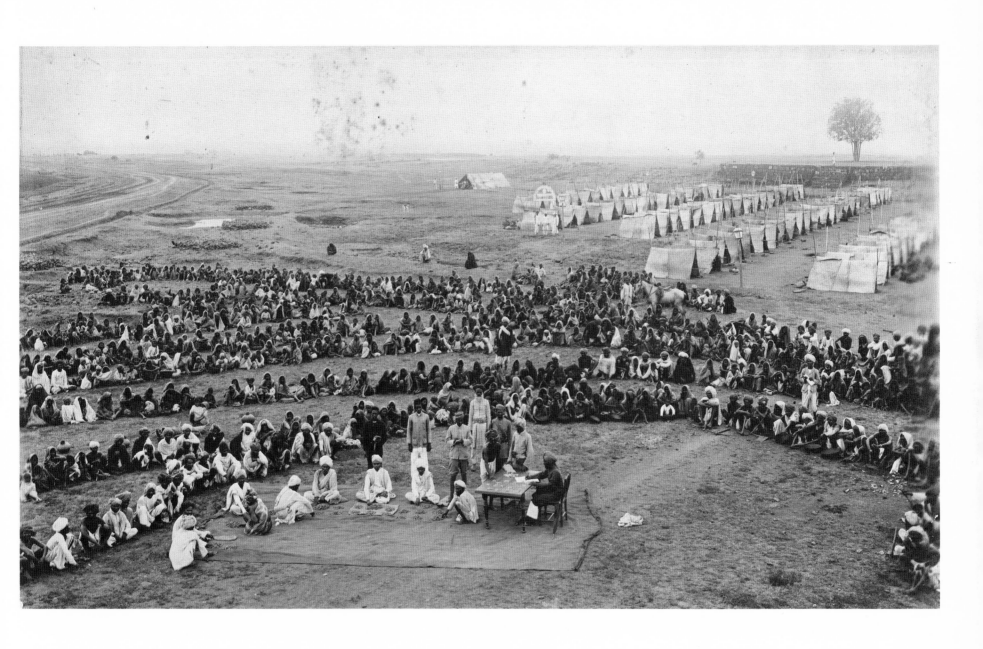

Famine relief camp, the Nizam's dominions, 1900.
The government of the Nizam set up model camps for the care and
feeding of famine victims within his domain.

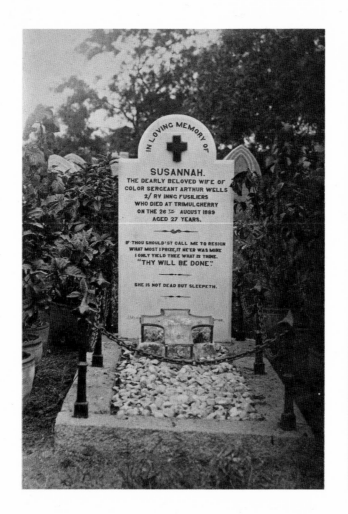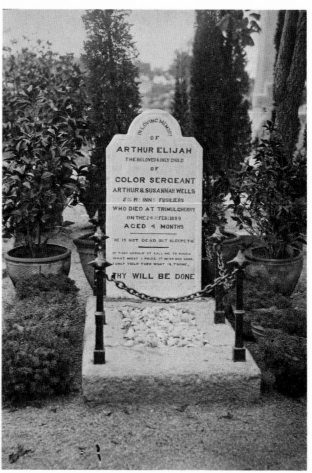

Graves of the wife and son of Arthur Wells, 1889.

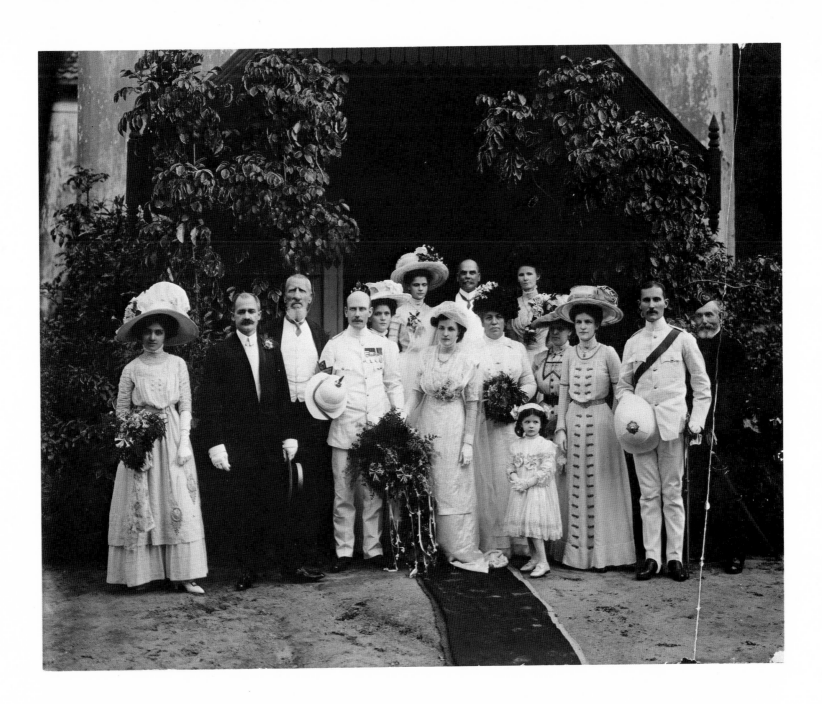

British wedding party, Secunderabad, 1900-10.

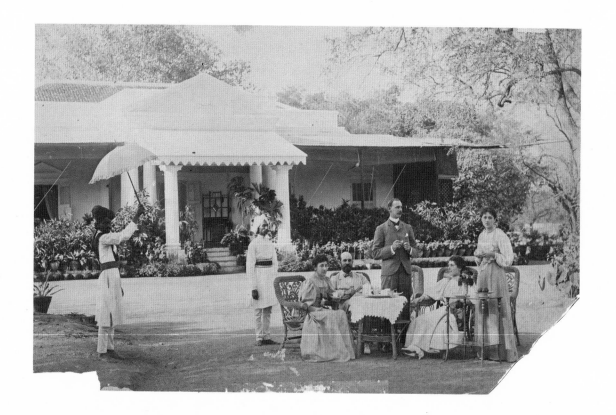

The social distinctions are by no means lost sight of in India; on the contrary, they are perhaps more rigidly observed here than at home, and the smaller the society the broader are the lines of demarcation. Each man depends on his position in the public service, which is the aristocracy. . . . The women depend on the rank of their husbands. Mrs. A_____, the wife of a barrister making £4,000 or £5,000 a year, is nobody as compared with the wife of B_____ who is a deputy commissioner, or with Mrs. C_____ who is the better-half of the station-surgeon. Wealth can do nothing for man or woman in securing them honor or precedency in their march to dinner. . . . A successful speculator or a merchant prince may force his way into good society in England . . . but in India he must remain forever outside the sacred barrier, which keeps the non-official world from the high society of the services.

From *My Indian Mutiny Diary*, by
William Howard Russell

Above Garden party, Secunderabad, 1900.

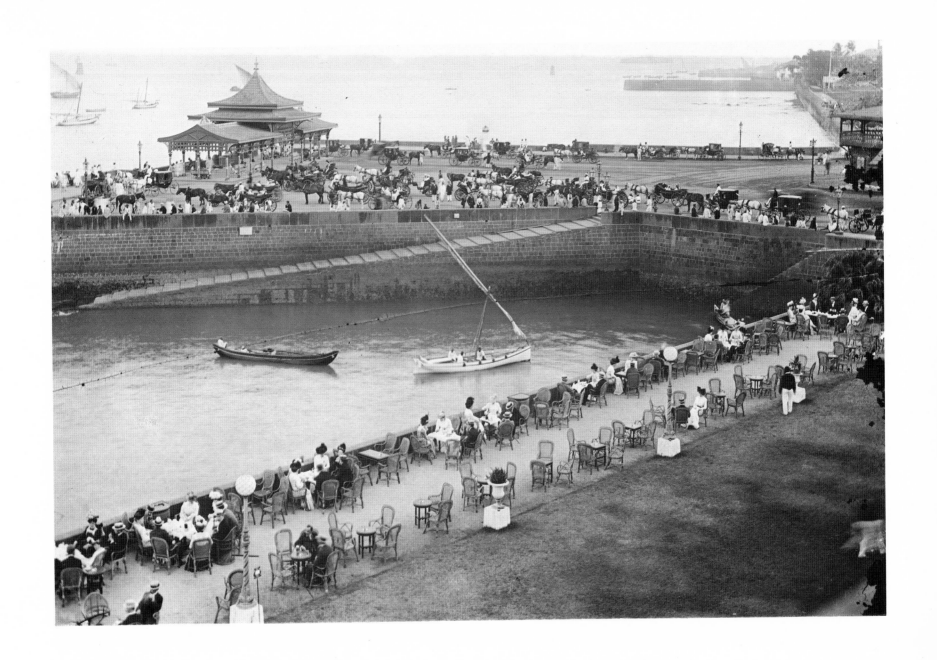

The Gateway of India, view from the yacht club, Bombay, 1890's.

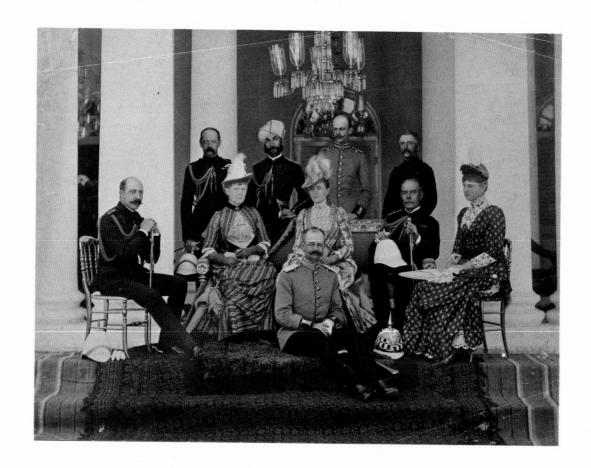

The repast itself is as costly as possible and in such profusion that no part of the table-cloth remains uncovered. But the dinner is hardly touched, as every person eats a hearty meal called tiffin at two o'clock at home. Each guest brings his own servant, sometimes two or three.... It appears singular to a stranger to see behind every white man's chair a dark, long-bearded, turbaned gentleman who usually stands so close to his master, as to make no trifling addition to the heat of the apartment.

From *The Sahibs*
edited by Hilton Brown

Above H.H. the Duke of Connaught (far left) and the royal party at Bashir Bagh Palace, Hyderabad, January 16, 1889.

Opposite Banquet, Hyderabad, 1890.

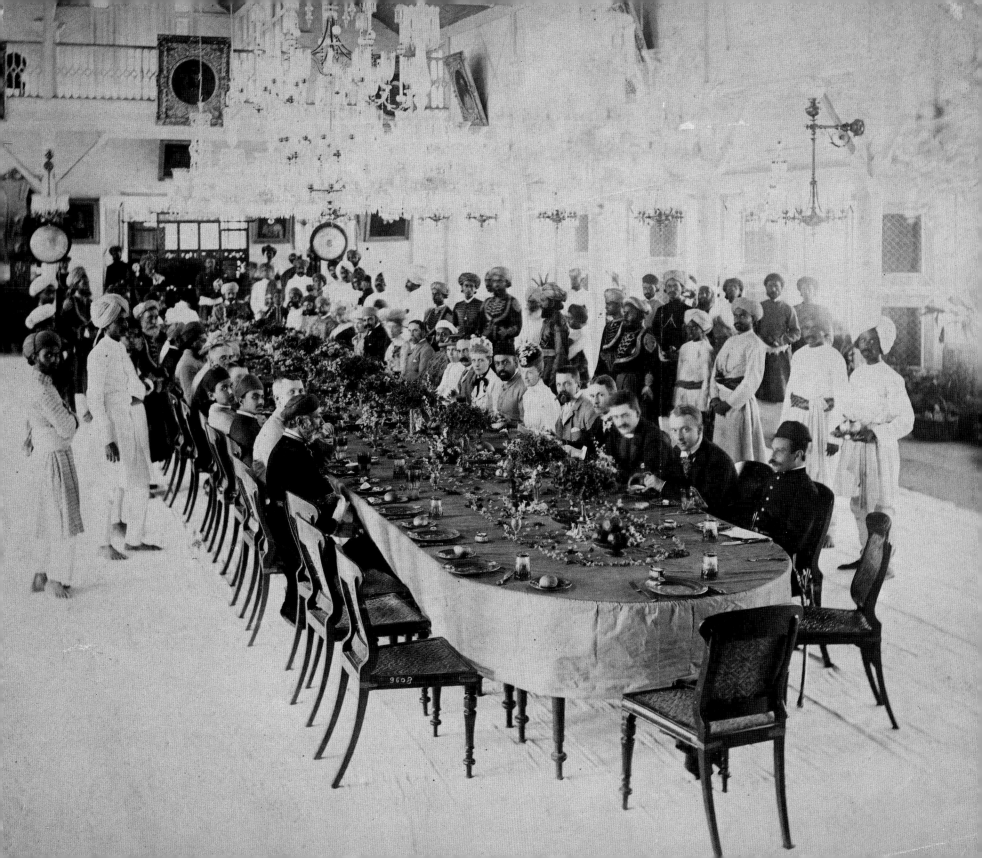

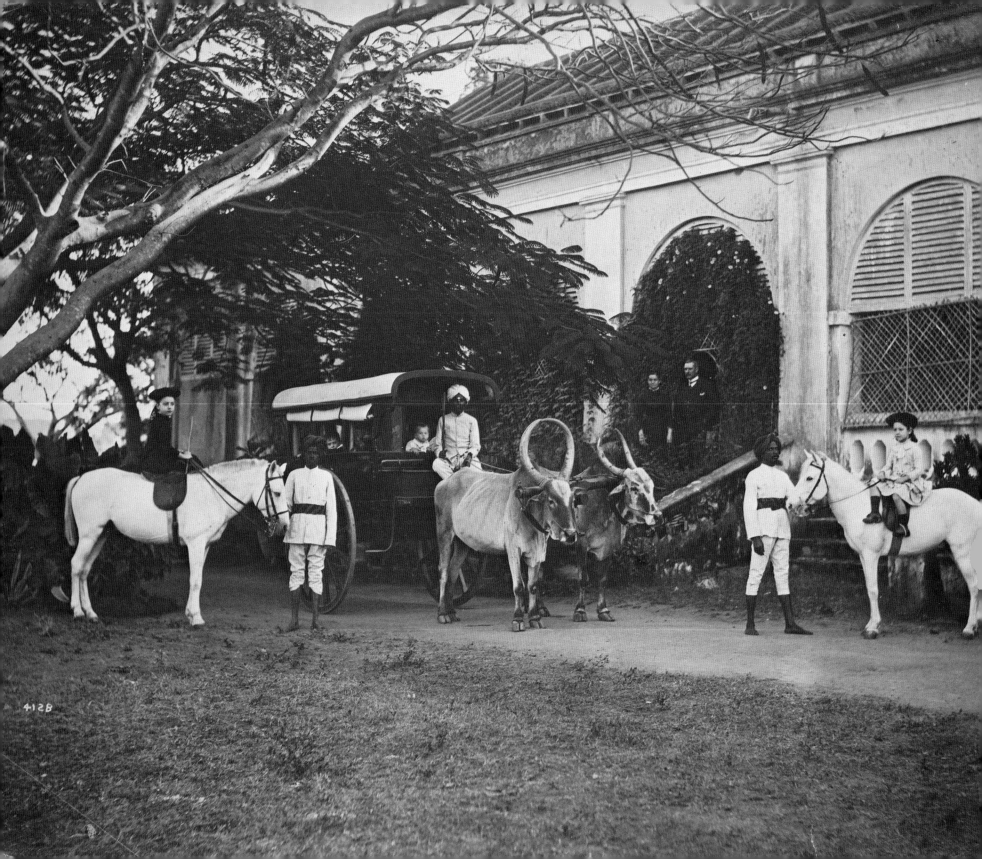

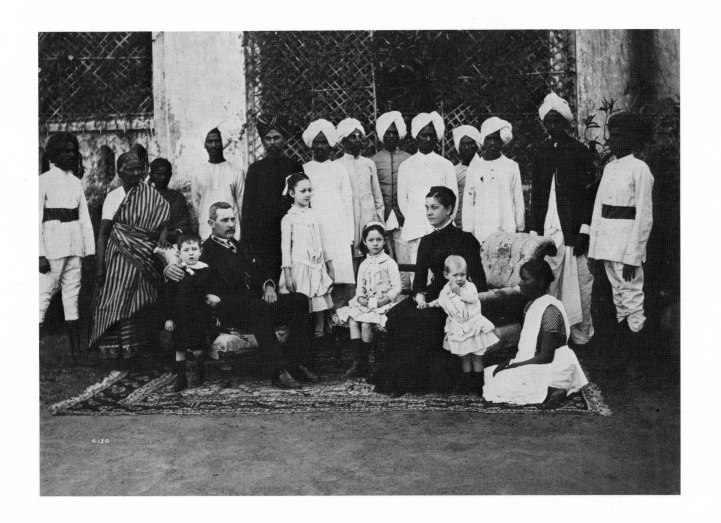

British family and domestic staff, 1888.

Opposite British bungalow and family, 1888.

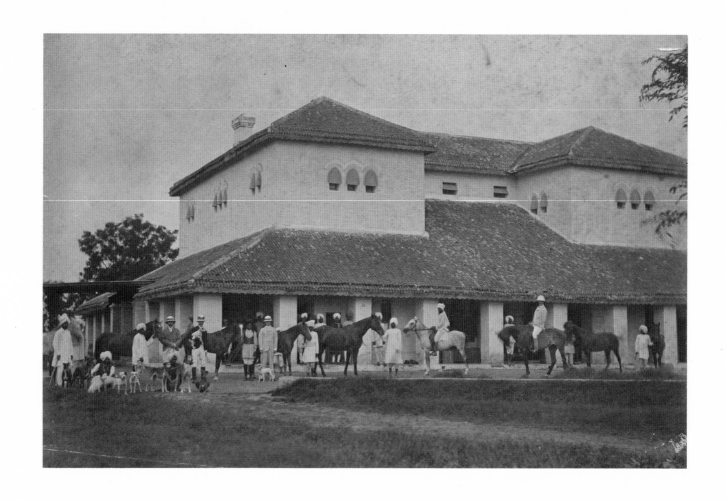

Members of the hunt in front of a bungalow, 1890's.

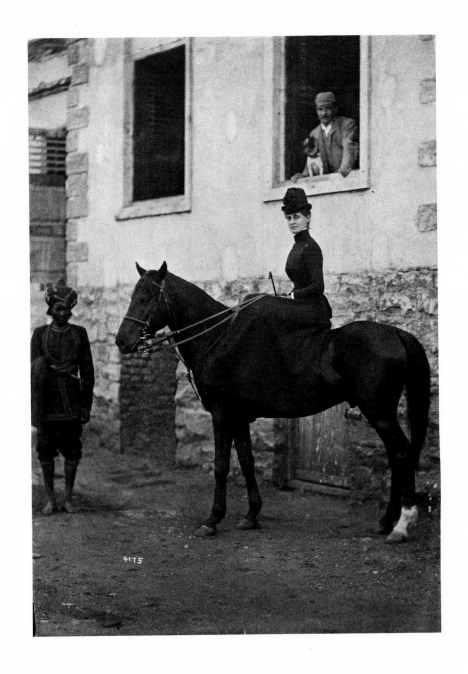

Englishwoman on horseback, 1888.

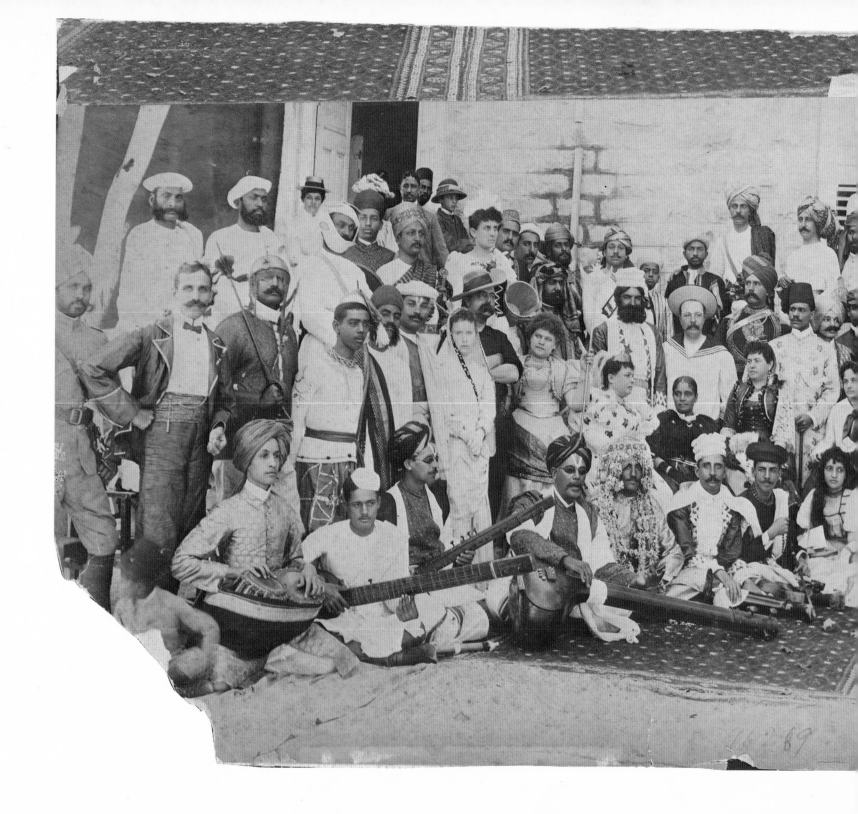

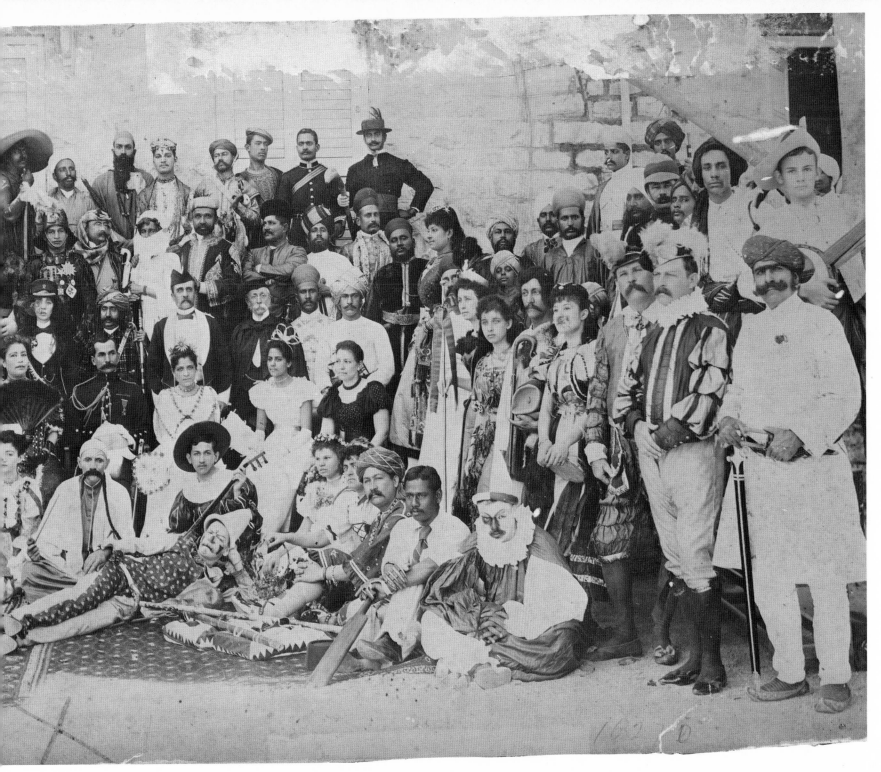

Masquerade, Secunderabad, 1892. During the period of the Raj, British masquerades were ubiquitous. However, this photograph is one of the rare examples of Englishmen together with Indians dressed in costume.

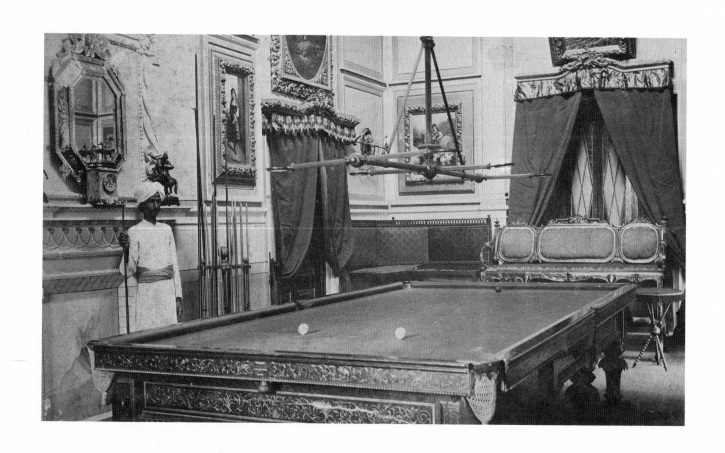

Interior, British Club, Secunderabad, 1890's.

Opposite Sergeant-Instructor Shaw, "S" Battery, Royal Horse Artillery, group of gymnasts, Secunderabad, November 20, 1906.

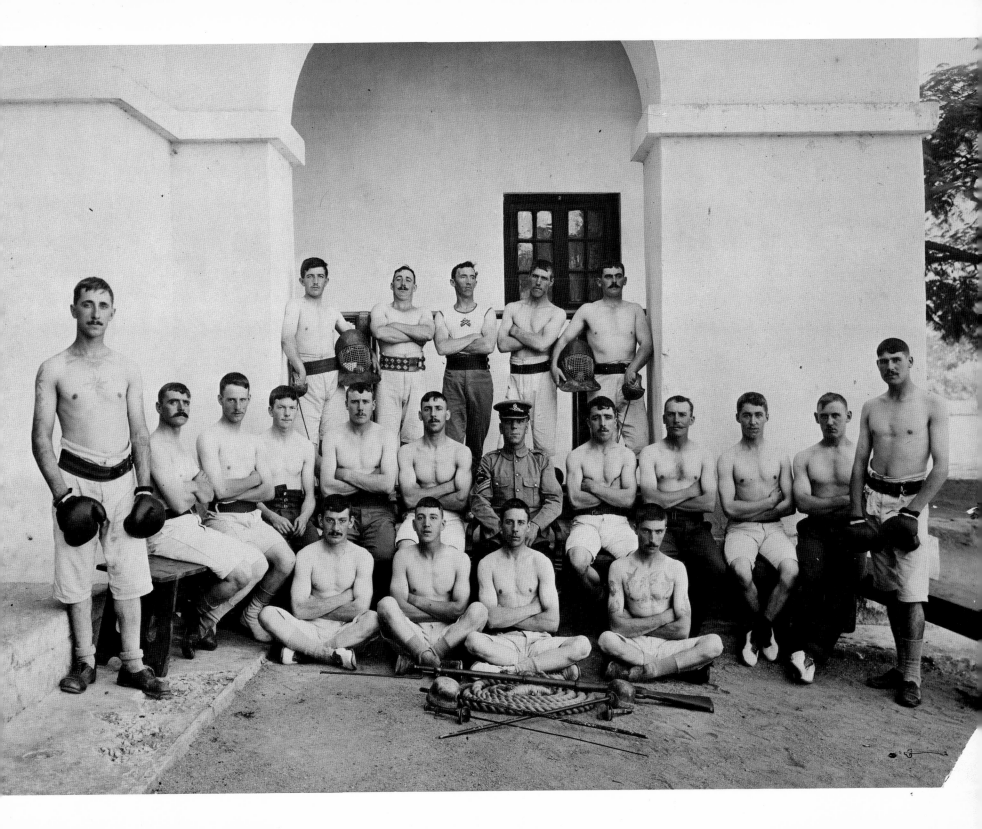

Anglo-Indian Games

Fire Alarm an amusement of the officers' mess which 'breaks the monotony of existence, particularly for the Victim': Raggers are divided into two parties, one of which moves outside the mess while the other waits until the victim is comfortably settled inside at whist. A cry of 'Fire!' is raised, followed by shouts of 'Smith (or whatever the victim's name is) is on fire!' Everyone inside then rushes at Smith and pitches him violently out the window to be caught by the other band of raggers. Sometimes, however, an amusing mistake occurred and the victim would be thrown out the wrong window.

<div align="right">

Adapted from *British Social Life in India*
by Dennis Kincaid

</div>

Promotion Remove a senior officer's chair as he is about to sit down.

Charity Place a funnel in someone's trousers and bet him that he cannot drop a coin into the funnel from his forehead. Pour someone else's drink down the funnel.

Asparagus Go to someone else's party. Eat all the asparagus out of the sandwiches and replace with your host's cigarattes.

Ice If you see anyone sleeping under a tree, place a lump of ice on top of his mosquito net.

Fish Wire a kipper on the engine of someone's car, preferably under the bonnet.

Chicken Pop a chicken inside someone's mosquito net.

Affection Choose someone smaller than yourself. Wait for a guest night. Place Enos [Eno effervescent salts] in his bed, flour on his pillow and castor oil on his hair brushes. Choose someone you dislike and ask him at breakfast what he was doing in the Victim's room the night before. This sort of thing spreads good feeling in the mess.

<div align="right">

Quoted from *The India Leave Book*
by G. and P. Hall and H. Fooks

</div>

Opposite Polo team of the 33rd Cavalry, Secunderabad, 1908.

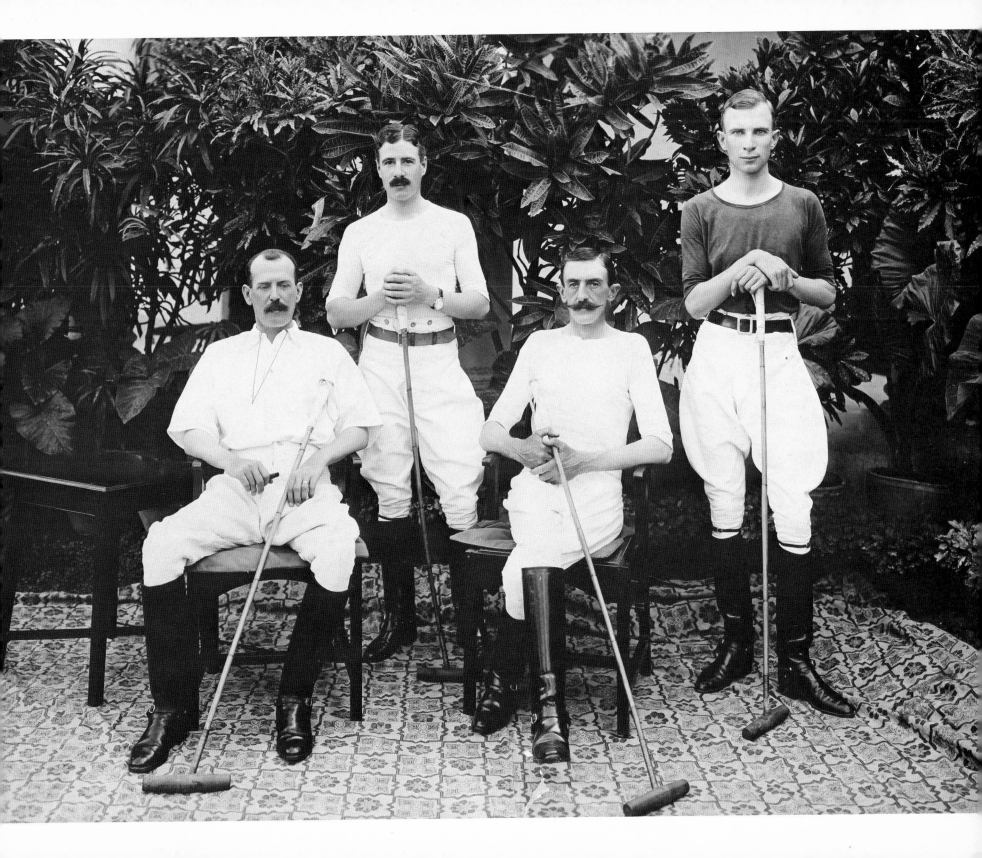

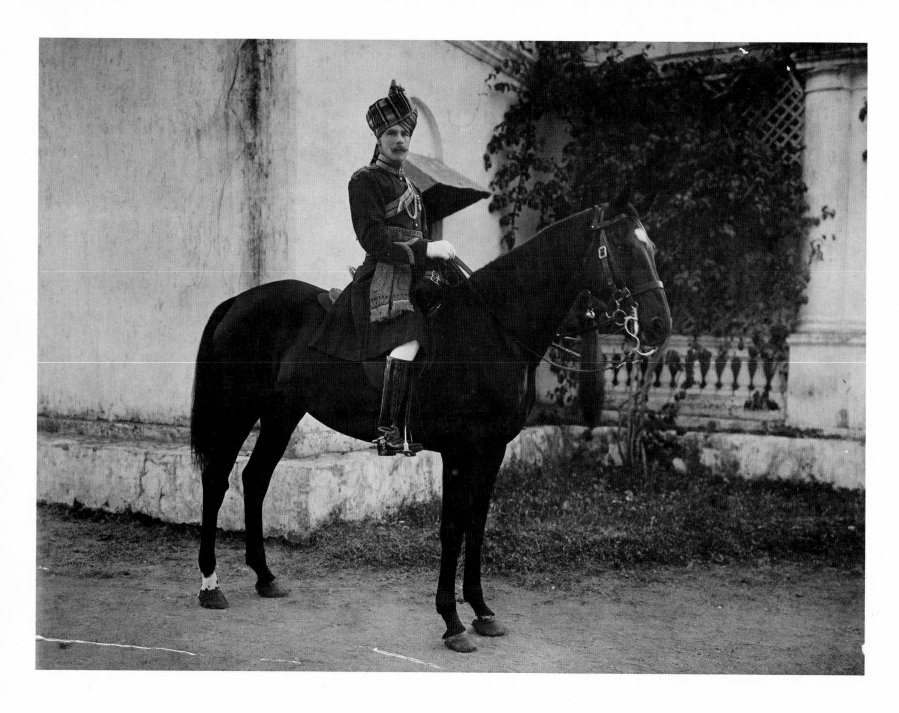

Captain H. H. Andersen, the 33rd Cavalry, Secunderabad, 1908.

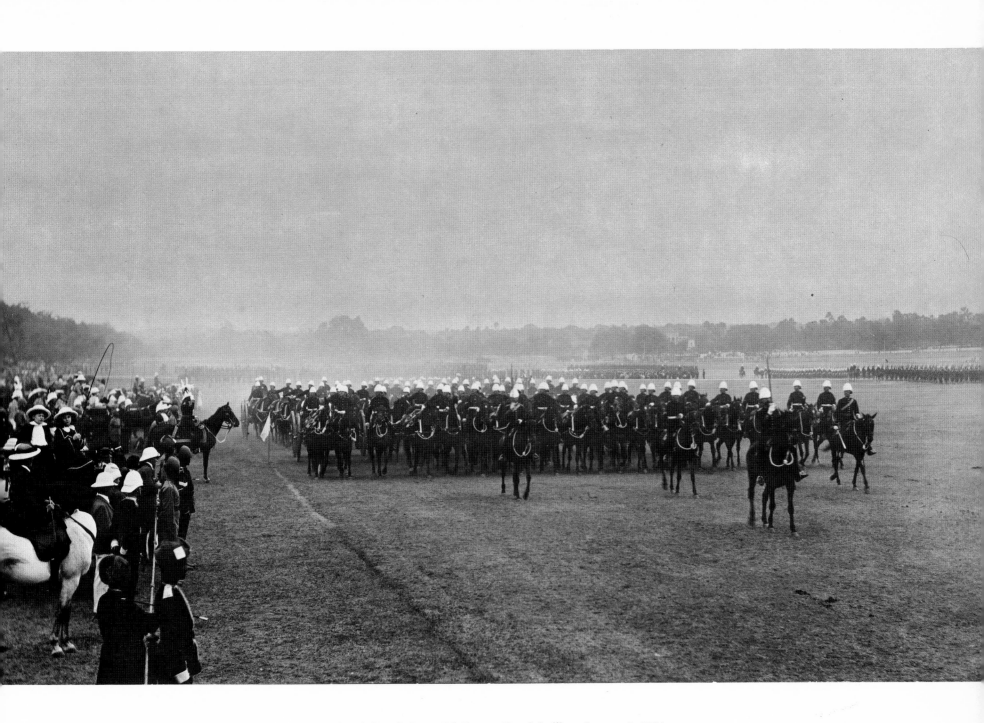

New Year's Parade Past, 49th Battery, Royal Artillery, January 1, 1904.

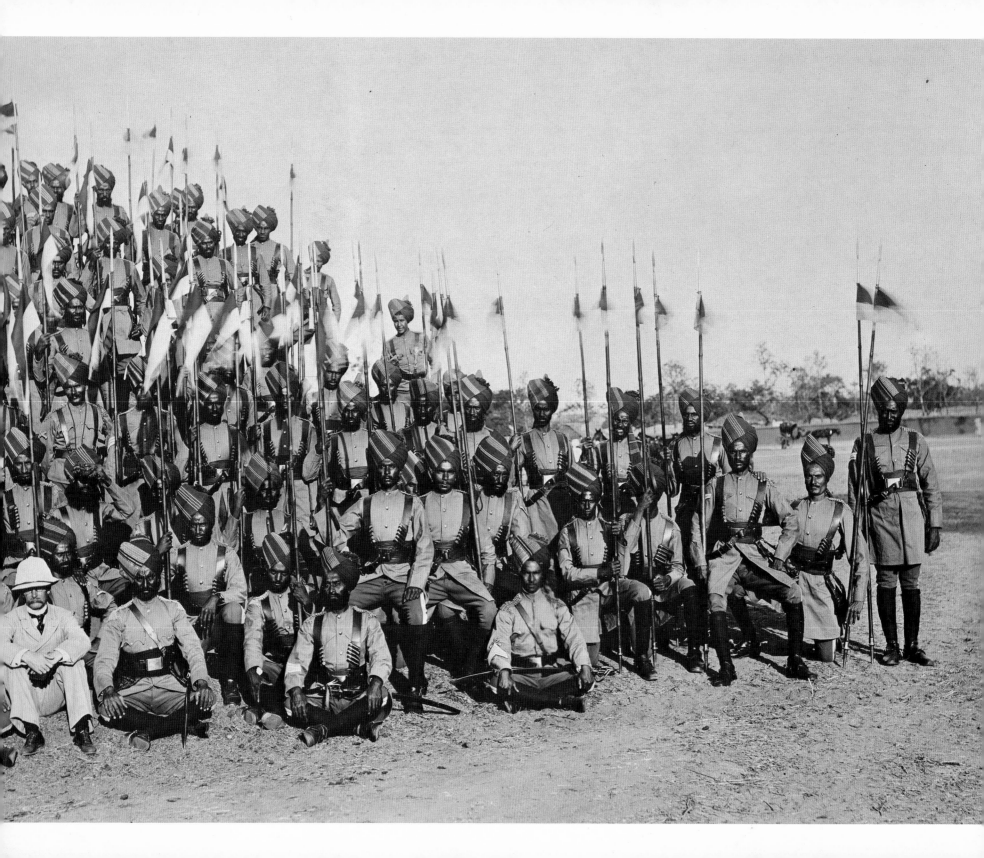

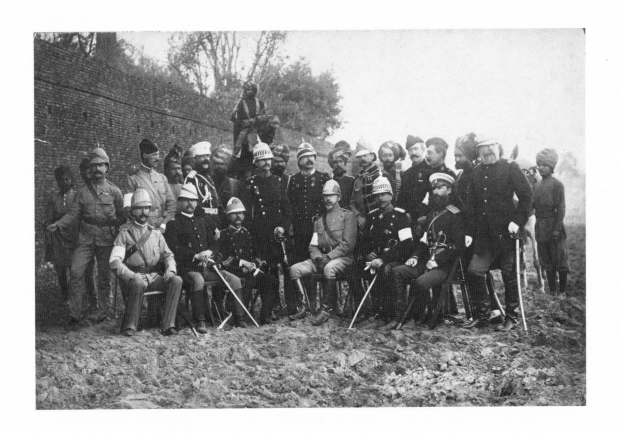

Foreign officer observers, Panipat Maneuvers, 1886.

Opposite Native lancers, Secunderabad, 1905.

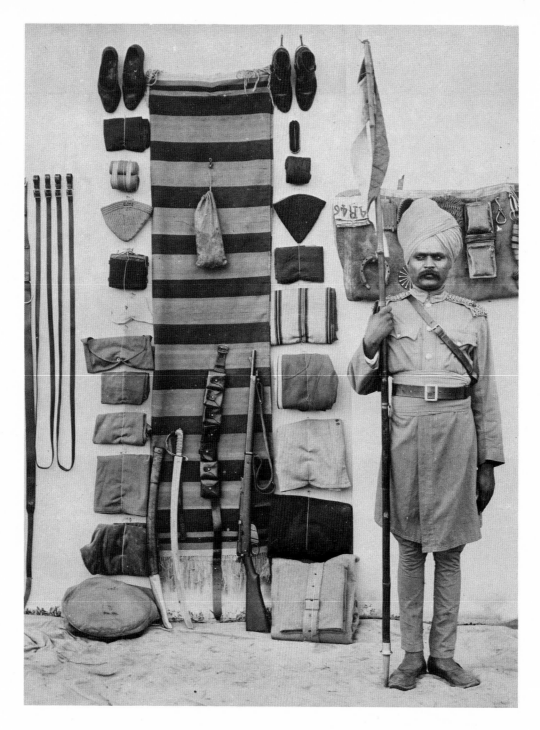

Native lancer and equipment, Secunderabad, 1905.

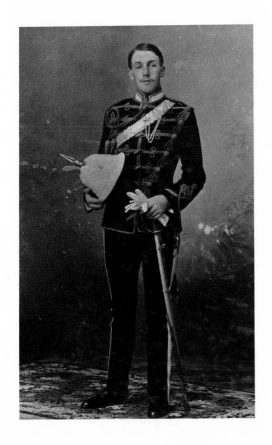

Lieutenant F. O. Oakes, May 7, 1908.

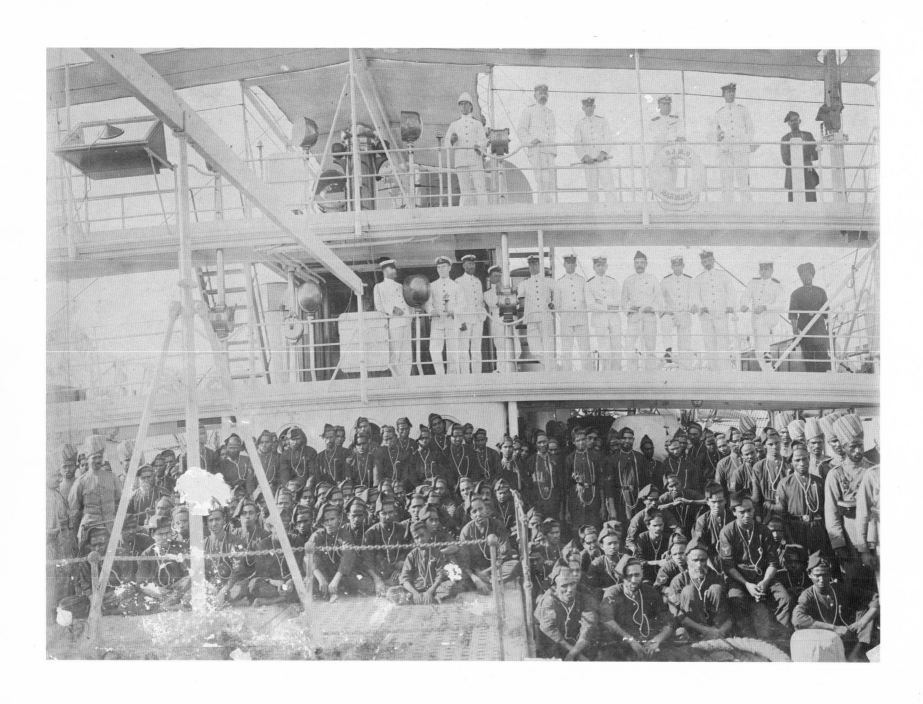

Officers and lascars, H.I.M.S. *Hardinge*, Lord Curzon's Persian Gulf tour, 1903.

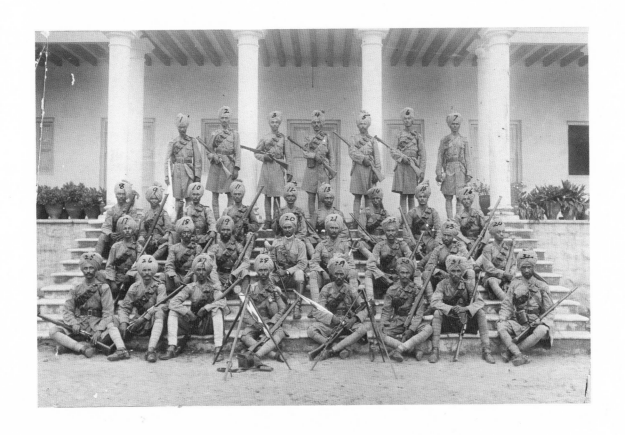

H.H. the Nizam's 2nd Lancers. These troops served in France during World War I.
Raja Gyan Chand, photographer, 1913.

In addition to performing the myriad official duties of a court photographer, Raja Lala Deen Dayal, along with his sons, operated his own commercial photographic establishments mainly for portraits, in Indore, Bombay, and Secunderabad. The photographs in this section of the book represent a sampling of this work, as well as photographs by Dayal of land-scapes and other subjects which interested the artist personally.

The following is a description of what took place when a client entered one of Dayal's studios. First, there would be the selection of a camera and plate size to fit the customer's budget. Most customers requested half plate 5″ x 6″ photographs (a negative size achieved by using the two halves of a 10″ x 12″ plate). For the more grandiose, there was a full plate size (10″ x 12″) of which each studio had three. The customer was then posed and "lighted," while a gelatin dry-plate negative was exposed. An approximate measurement of the sensitivity of these plates would correspond to a contemporary ASA rating of 10. Darkroom technicians would develop the plate or plates; printing technicians would then make proofs on printing-out paper (POP, as it is commonly called), usually preferring the British brands of Ilford, Illingworth, Wellington, or Cosmos. The proofs were subsequently studied by a retoucher who would correct them as he saw fit. The retouched negative would then be sandwiched into a printing frame against a piece of POP and exposed to sunlight (no enlargers were used). The proofs were then submitted to the customer for his or her approval, orders were taken, and the final prints produced and toned in a solution of gold chloride to ensure permanence.

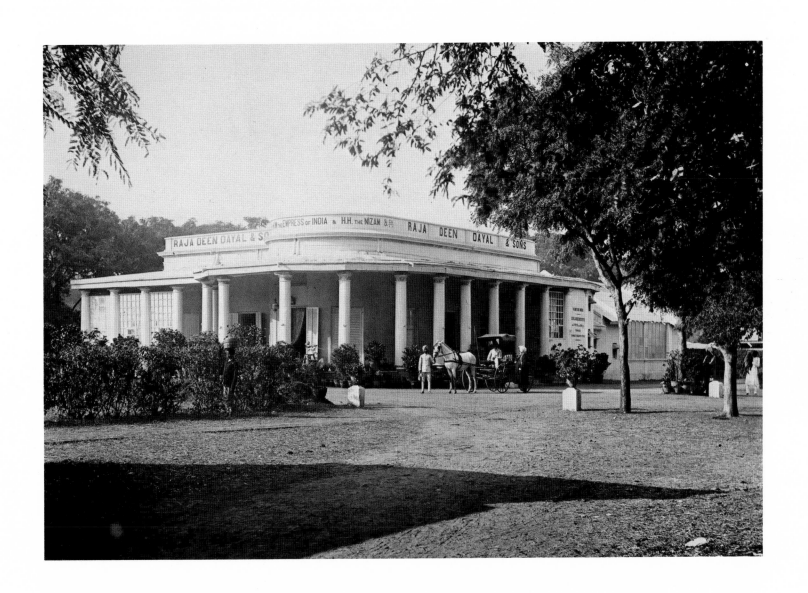

Studio of Raja Deen Dayal & Sons, Secunderabad, 1890's.

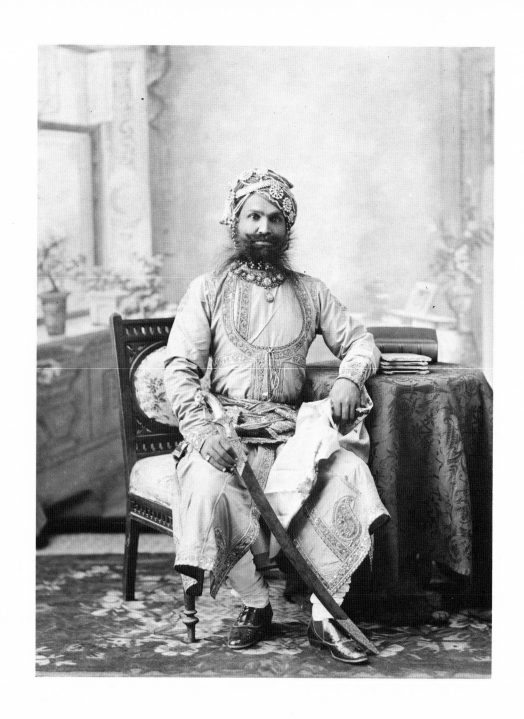

Rajput prince, 1890's.

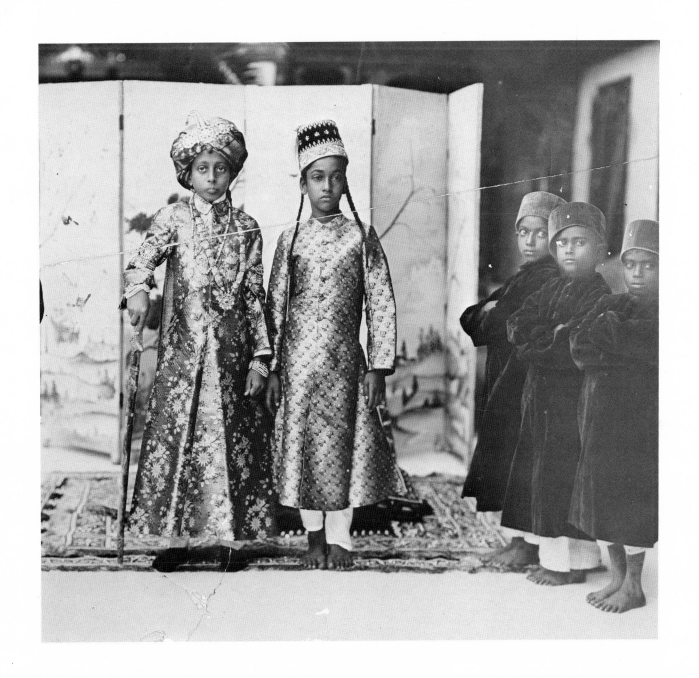

Two princes, with three attendants, 1890's.

Child, 1900.

Opposite The granddaughters of Raja Lala Deen Dayal, Secunderabad, 1890's.

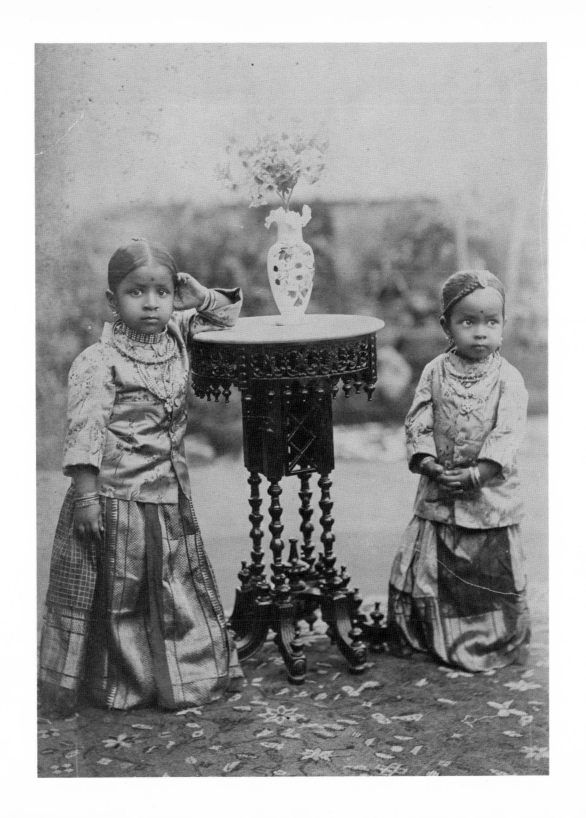

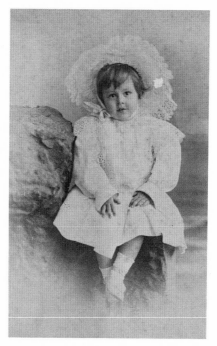

How To Compose A Child, Six Months Old For An Exposure: Place the infant on a table, and a stout pillow behind it, well supported. Place also a pillow on either side, so that the child has something to lean against and rest upon. Now dip each hand of the little model in a pot of molasses, and afterward the left hand in a bag of feathers. The child's attention is now rivetted upon the plumed hand, holds it up in astonishment, and, taking courage, begins to pick each feather from the left hand; but each one taken off naturally adheres to the right hand, and thus the play commences repeatedly from one hand to the other for an hour or two, slowly and deliberately, giving you ample opportunity to make an artistic exposure. It is a wonder that this has not been patented; the plan is altogether ahead of giving a child a tallow candle to eat, or frightening it with an exhibition of Punch and Judy.

<div align="right">Professor Towler, "Humphrey's Journal," reprinted
in the British Journal of Photography, July 5, 1867</div>

Above Child, 1890's.

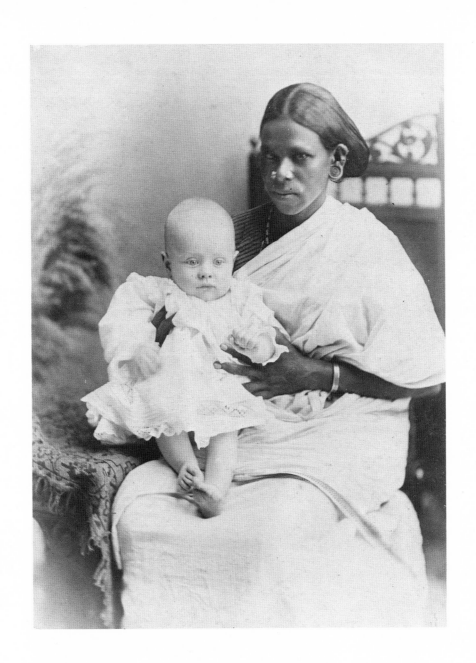

Ayah (nursemaid), with European child, 1890's.

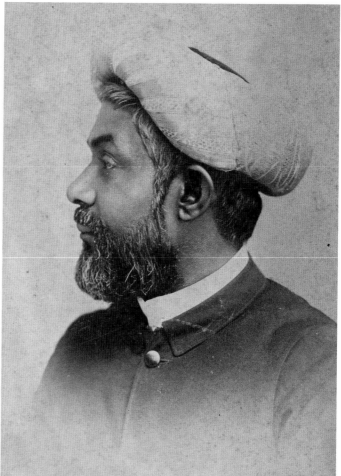

Man with *Bora* headdress, 1890's.

Opposite Court functionary, Hyderabad, 1890's.

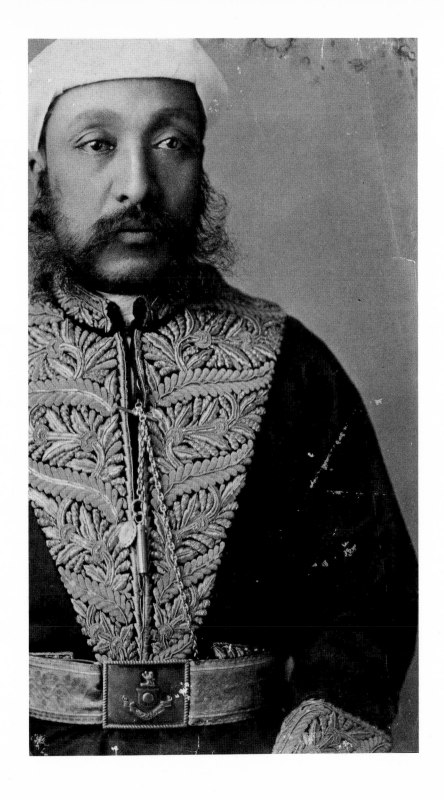

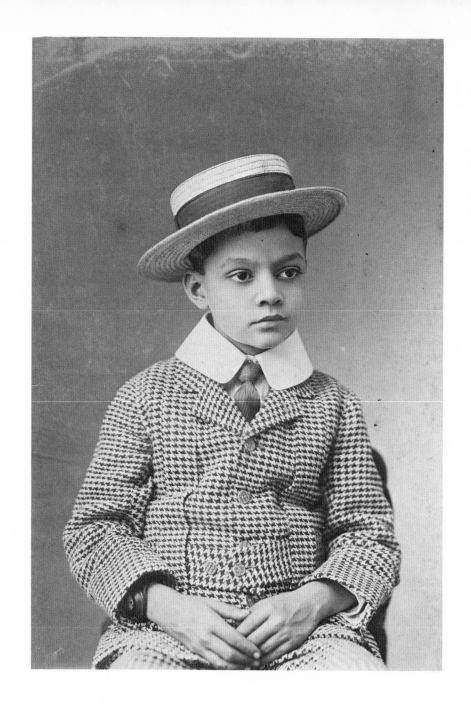

Indian boy, 1902.

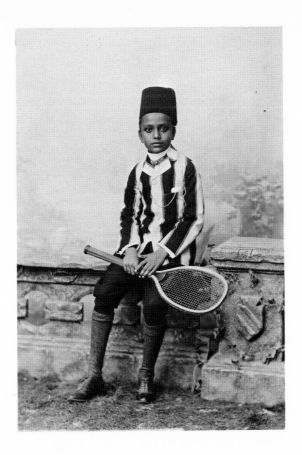

With the ascendancy of the British, the young nobility of Hyderabad were brought up with one foot in the English world and the other in the Muslim world. Accordingly, a young man dressed in the European fashion of the Victorian era and was taught to eat at table with European utensils and plates. European kitchens were built, and Goanese cooks were brought from Portuguese India to prepare bland dishes so dear to the British. Inexorably, all males of the noble families took to the cultivation of the attributes of proper British gentlemen, and Hyderabad became the lucrative haunt of bevies of Goanese cooks, English tutors, and European governesses. Along with English manners and traditions a youth imbibed a healthy love of British games that included badminton, lawn tennis, billiards, and golf.

Above Mahmud Ali, son of Nawab Intikabjong,
Hyderabad, June 2, 1899.

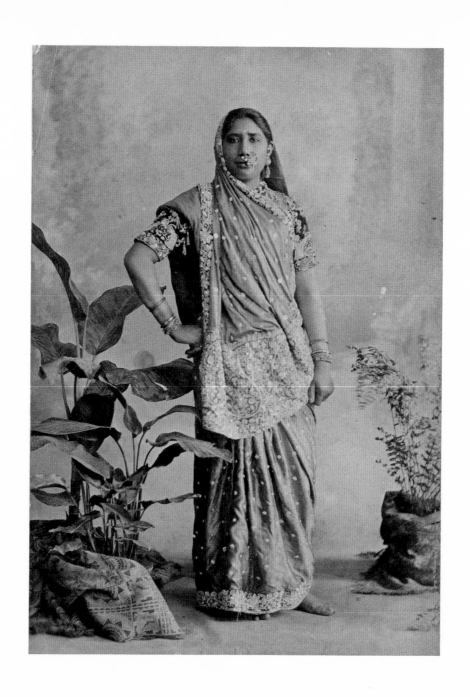

Gulnar, an old actress, June 18, 1901.

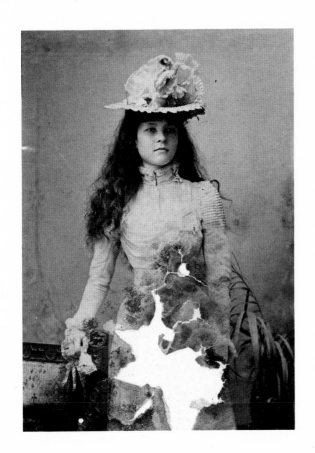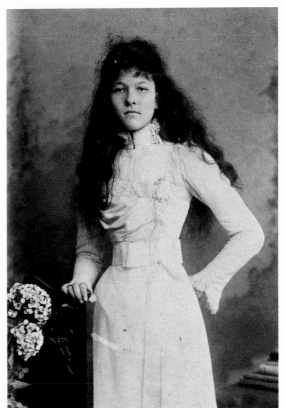

Miss Cricheon, c/o W. H. King, Goul telegraph office, 1901.

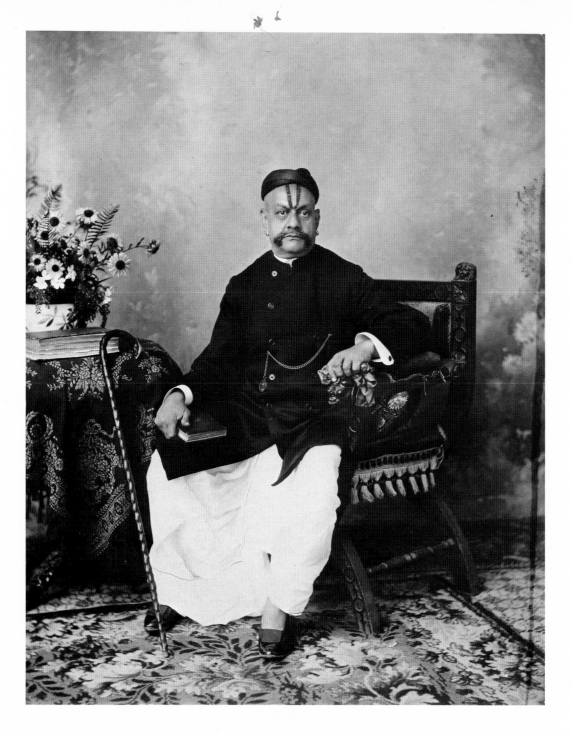

The banker Raja Bagwan Dass, 1900.

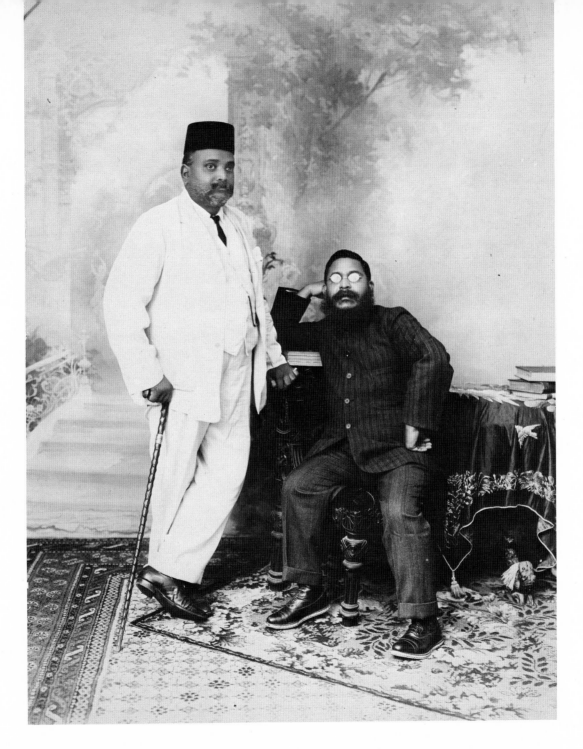

Babu Murlindhar, a finance officer, with Pyarelal, a lawyer, Hyderabad, 1910.

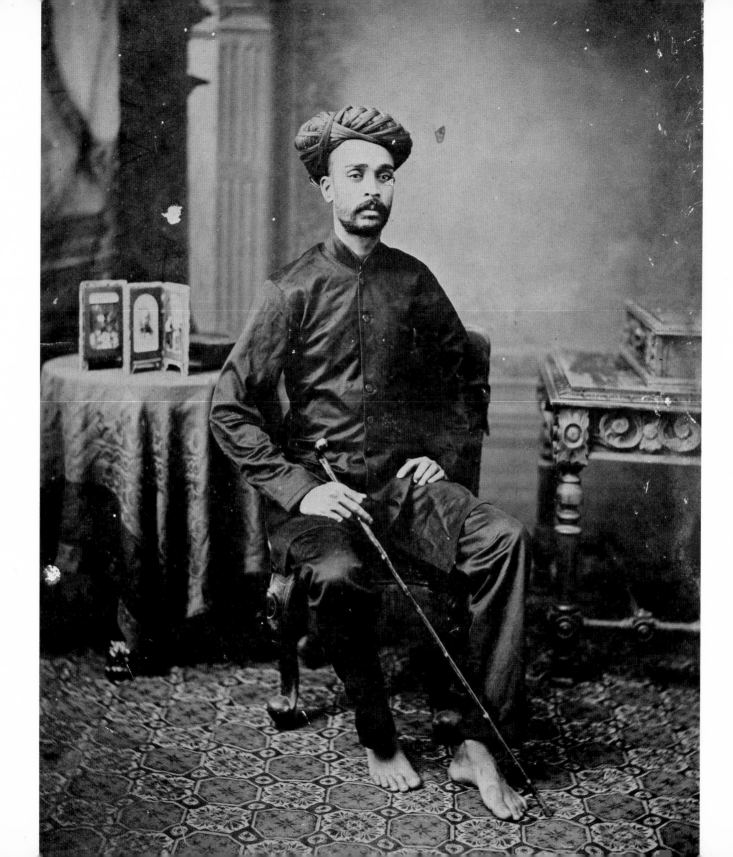

112

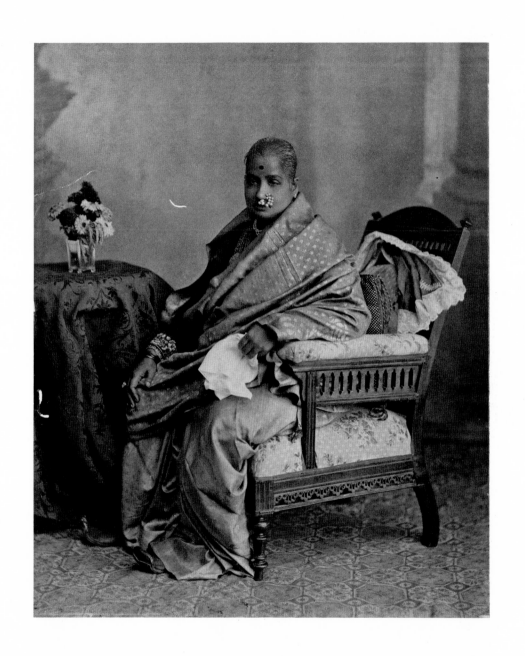

Studio portraits, Bombay, 1890's.

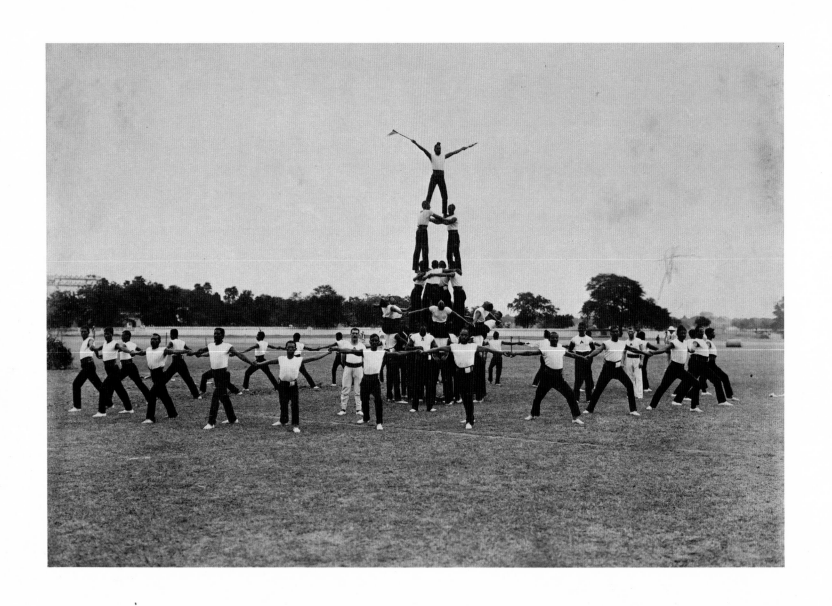

Military gymnastic exercises, Secunderabad, 1900-10.

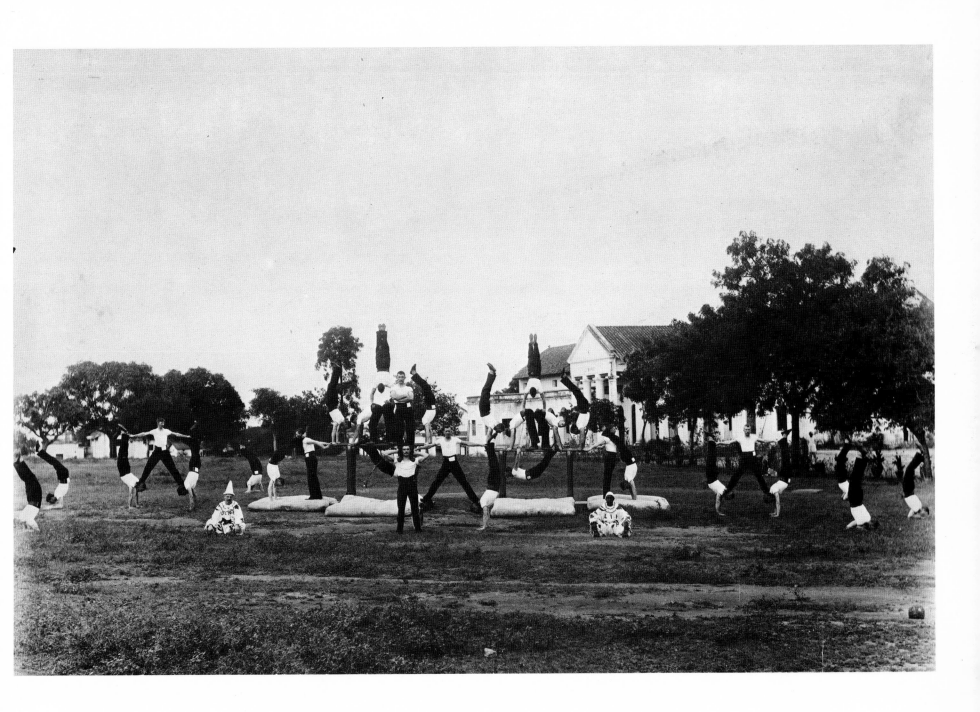

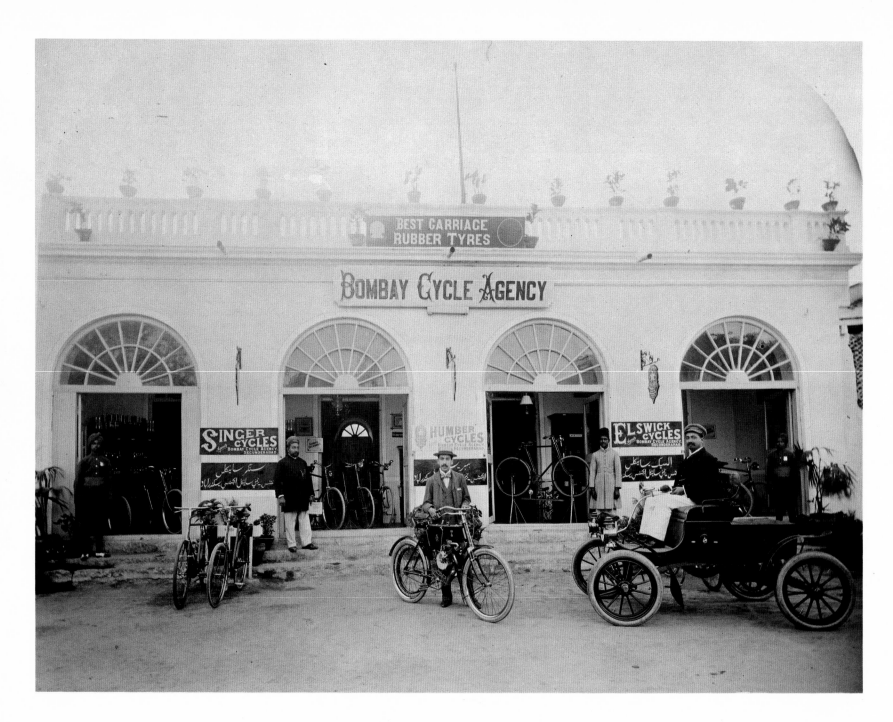

Bombay Cycle Agency, Secunderabad, February 24, 1904.

Opposite Nobleman with motorcar, Hyderabad, 1900's.

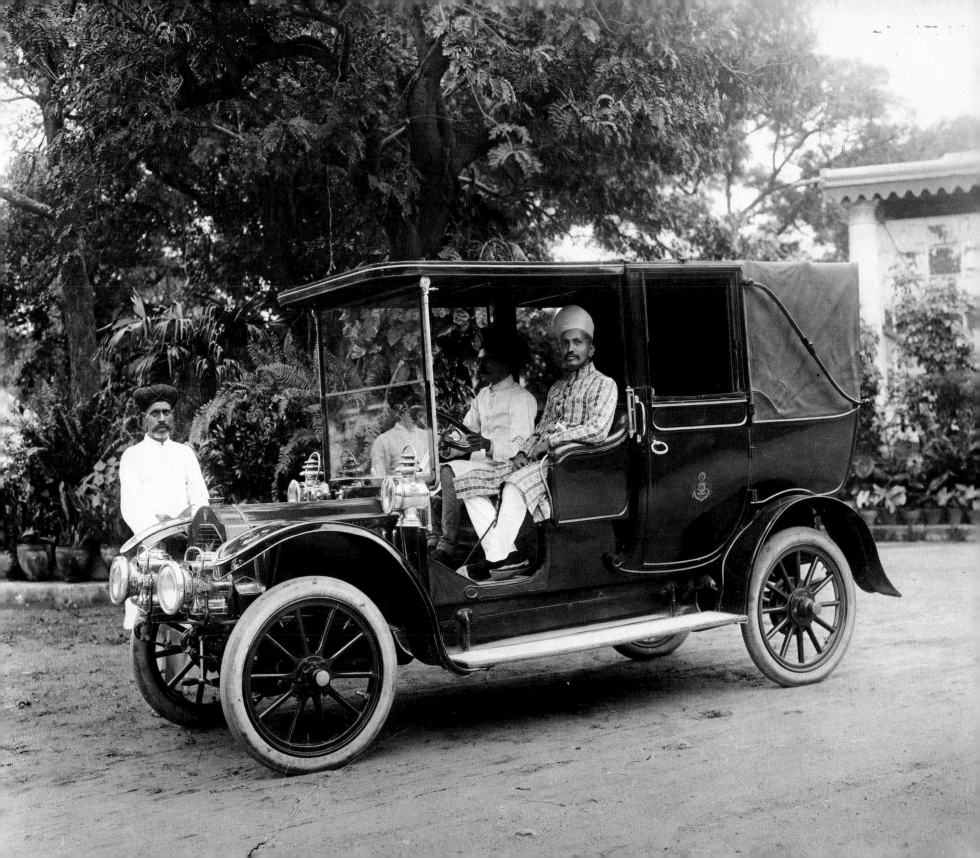

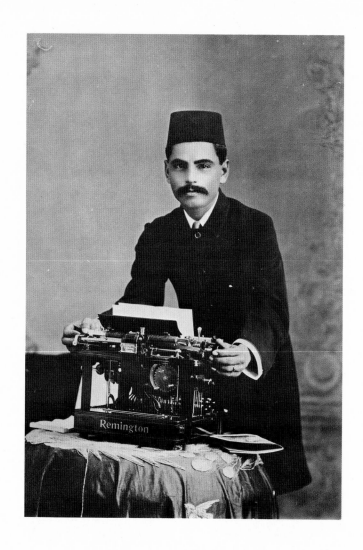

Salesman and automatic writing machine, 1900-10.

Opposite Demonstration of the new American treadle phonograph, Hyderabad,
May 22, 1892.

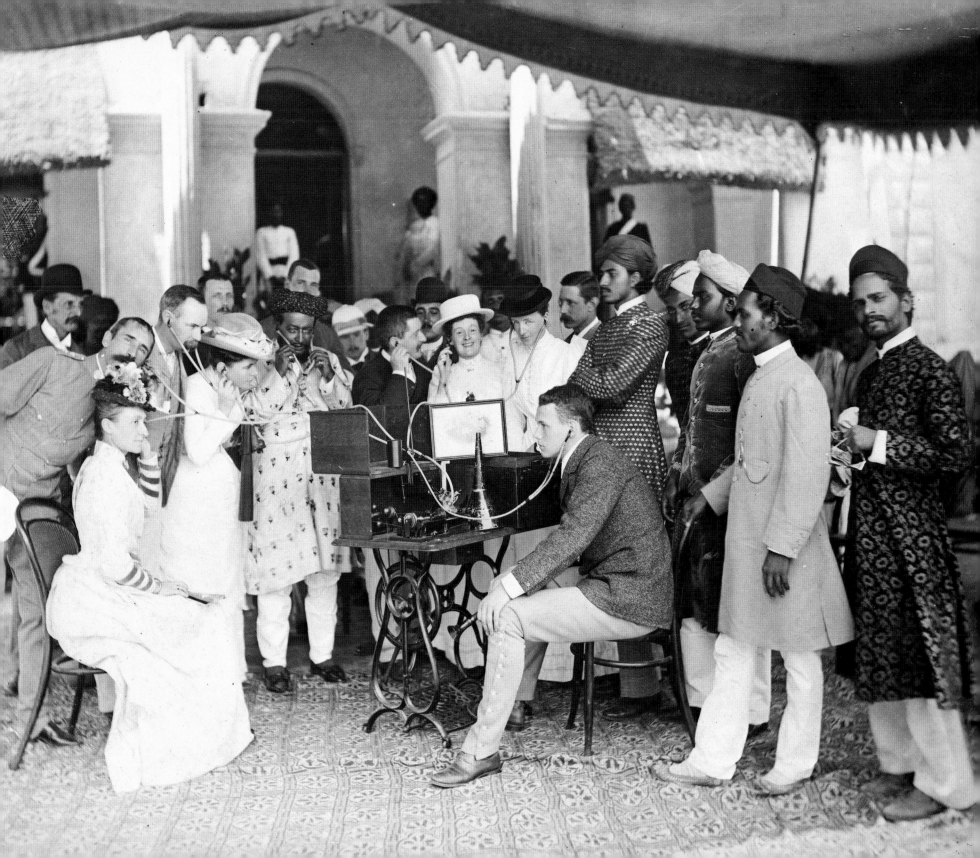

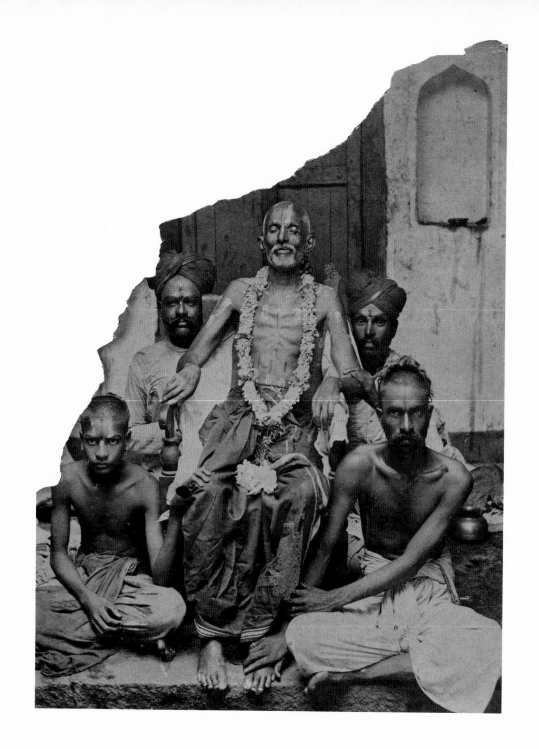

Luchmiah Rungiah and attendants, 1890's.

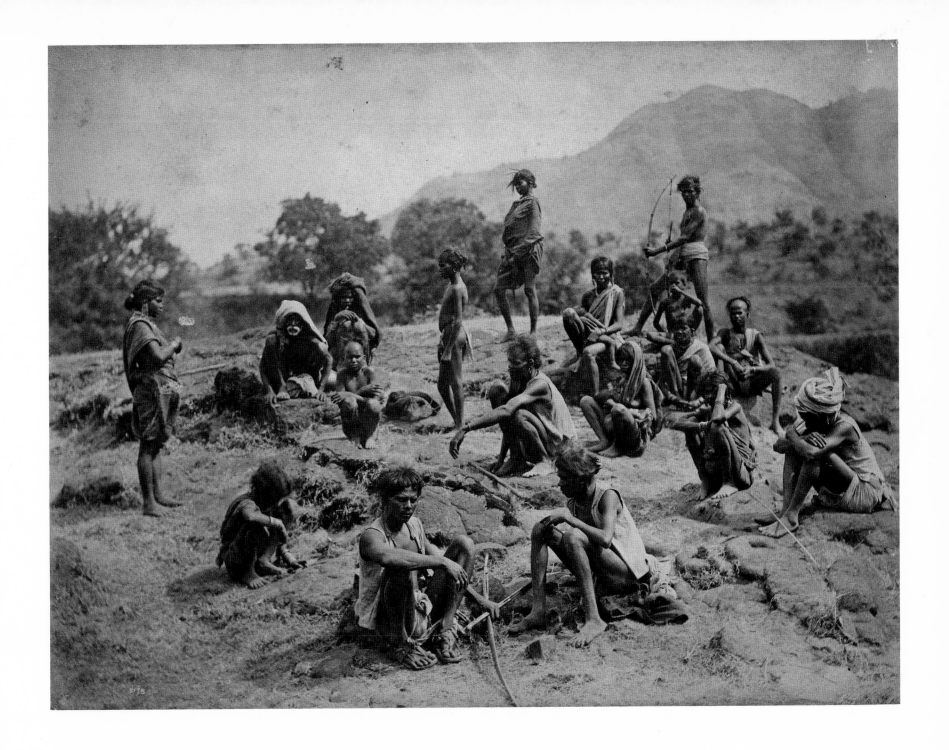

Bhil aboriginals, Central India, 1879.

Official, 1884.

122

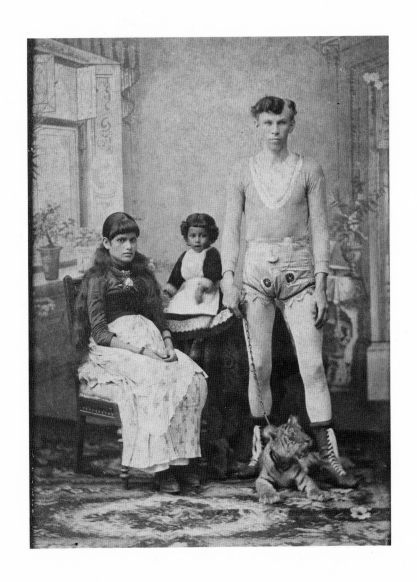

Circus performers, 1890's.

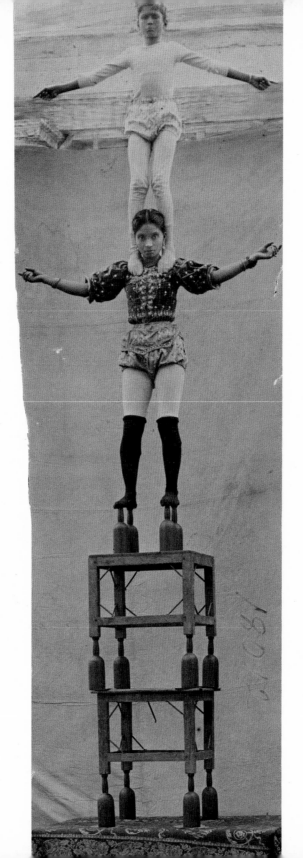

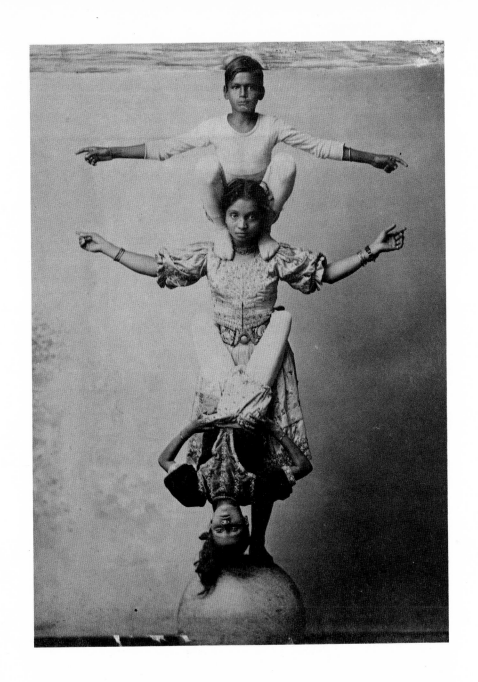

Members of the Chateri Circus, 1901.

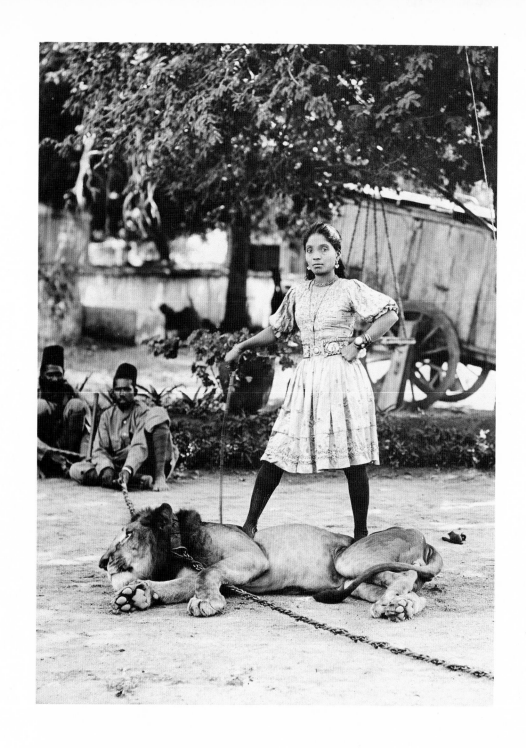

Lion tamer, Chateri Circus, October 4, 1901.

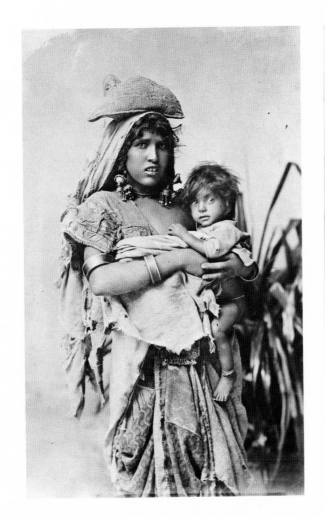 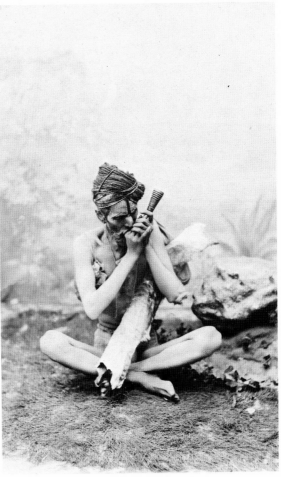

Left Tribal woman and child, 1889.
Right Fakir smoking *ganja* (Indian hemp), 1889.

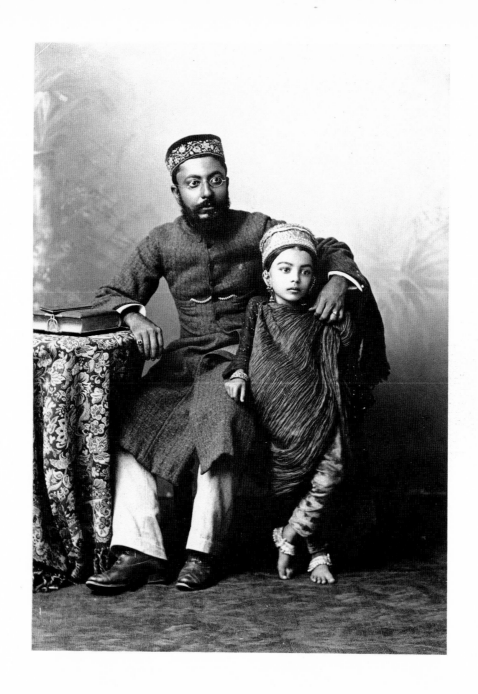

Man with daughter, one of H.H. the Nizam's relatives or courtiers, 1898.

Opposite Indian beauty, in Victorian-Mogul costume, 1890's.

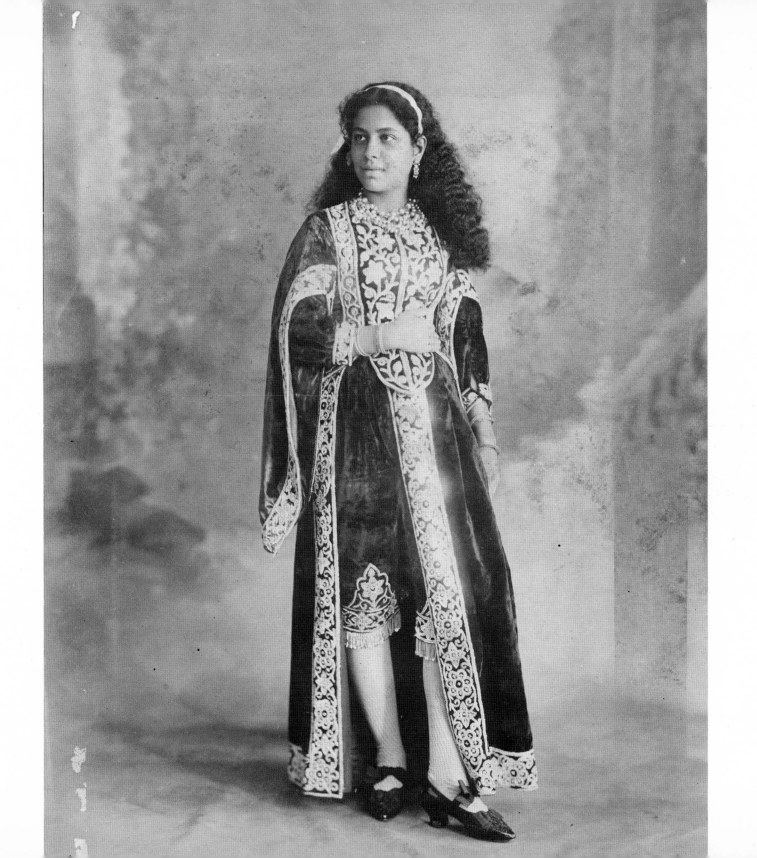

129

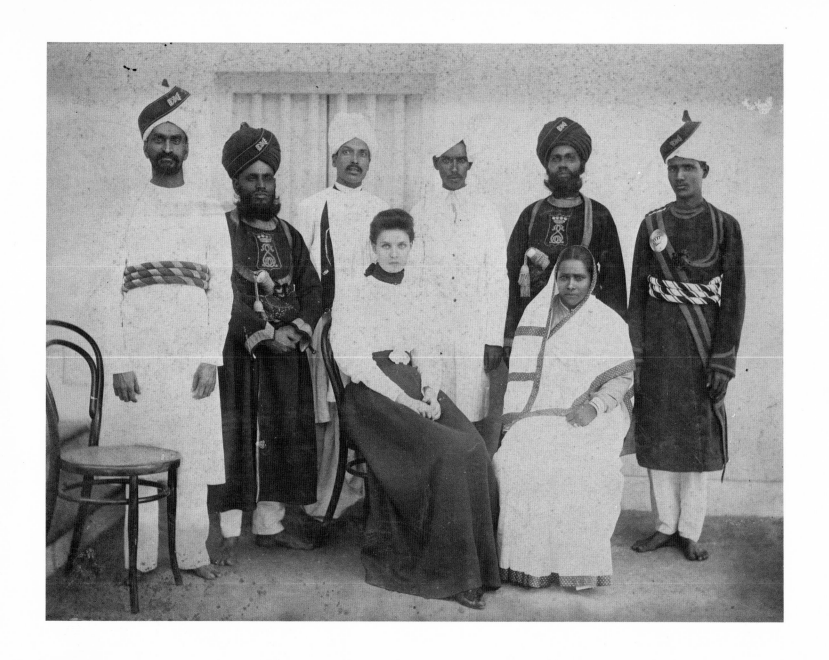

European and Indian servants, Hyderabad, 1890's.

Opposite Raghubir Singh, Maharaja of Bundi, with his courtiers, 1890's.

130

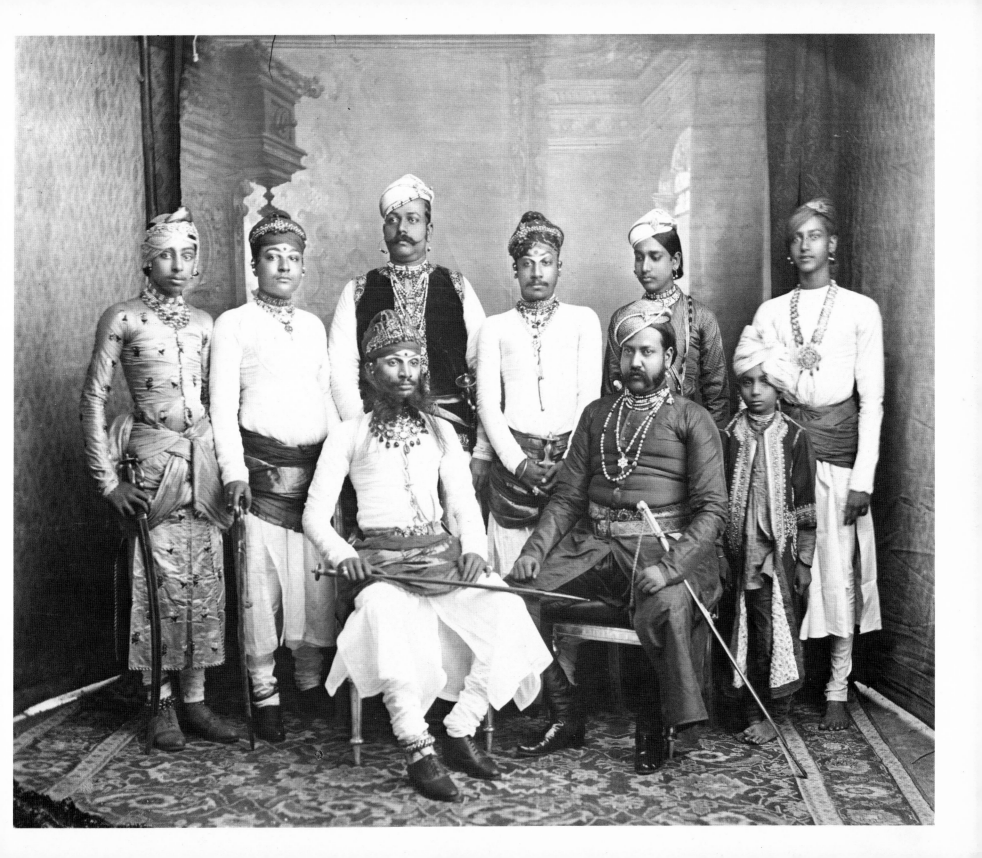

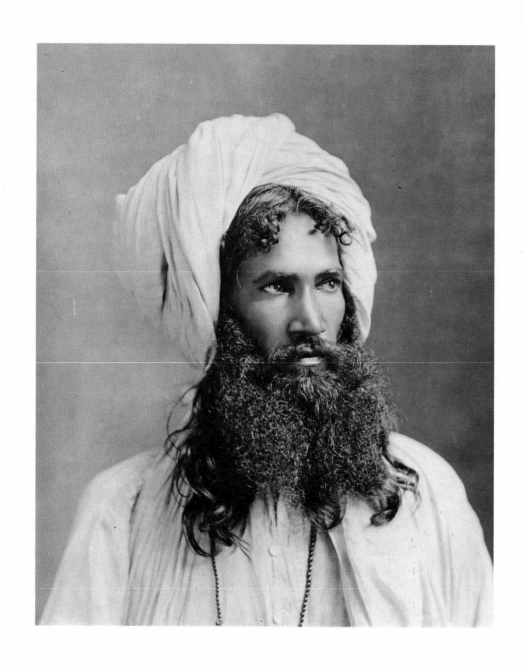

An astrologer, 1892.

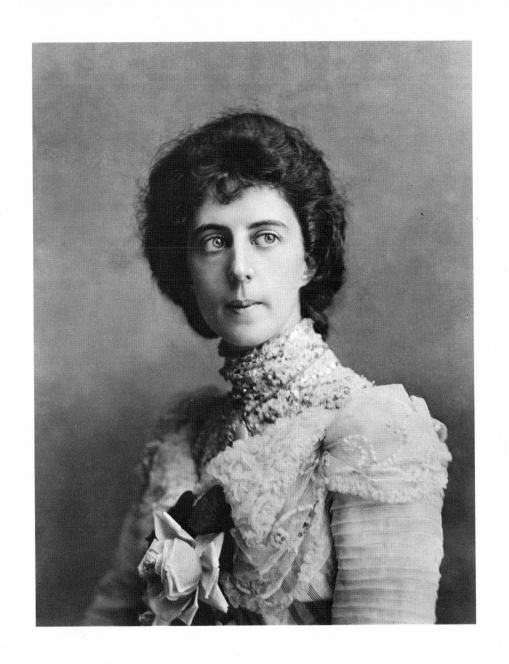

Lady M. Jenkins, 1900-10.

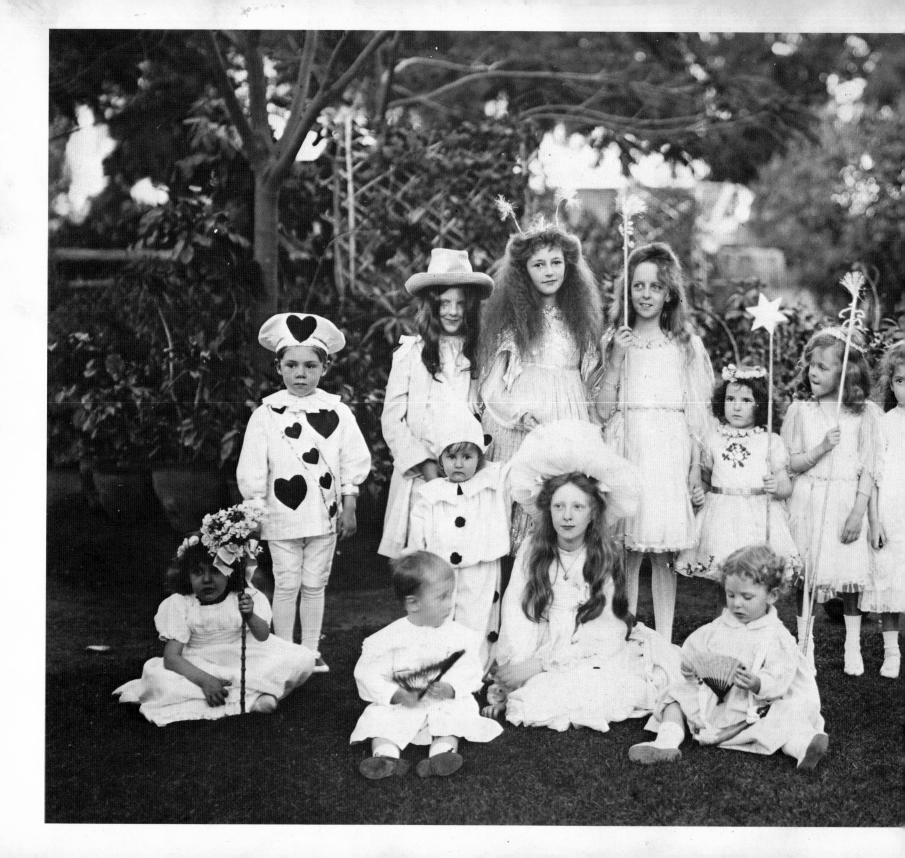

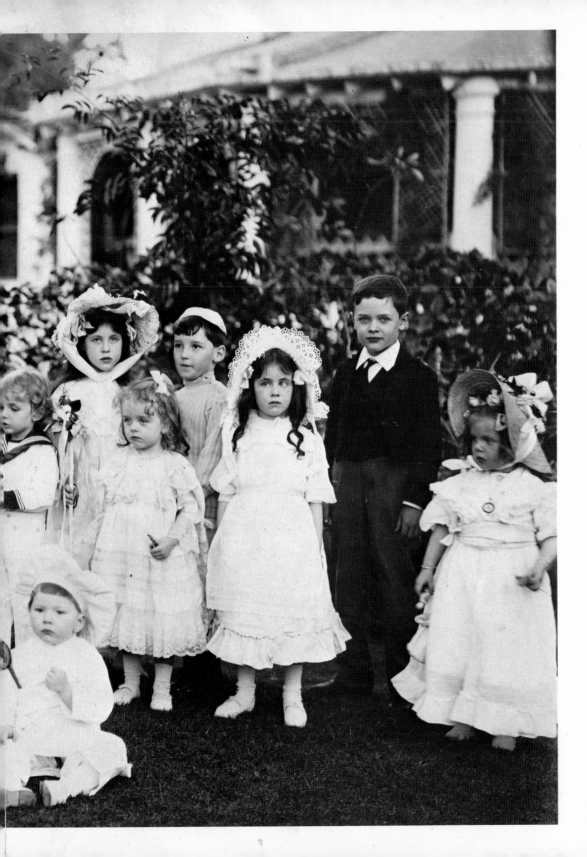

Fancy-dress children's party at Mr. Hankim's house,
Secunderabad, January 23, 1905.

135

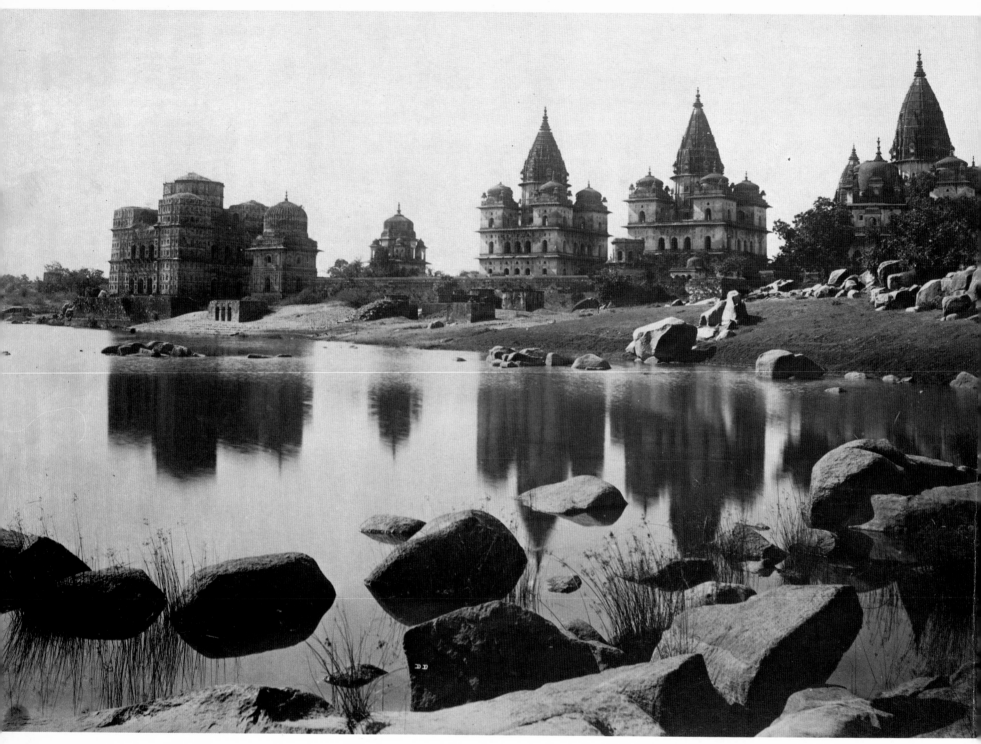

Sikhs at Nander Gurudwara, a famous Sikh temple and pilgrimage site.
Raja Gyan Chand, photographer, January 27, 1911.

Opposite Mausoleums of the Bundela chiefs, Orcha, 1882.

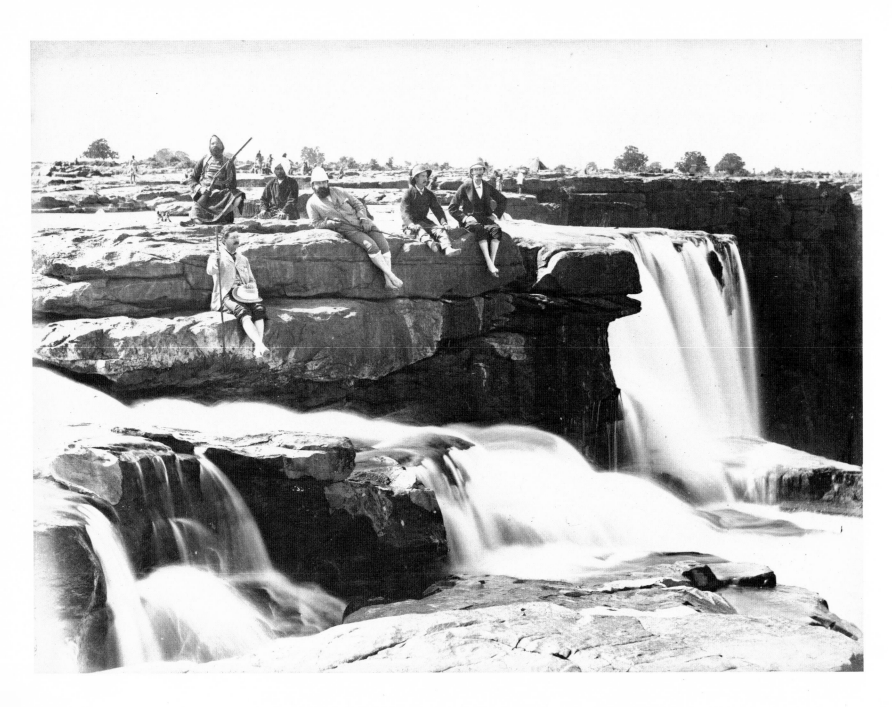

Sir Lepel Griffin (center) and party, at the Chichai waterfall, near Rewa, 1882.

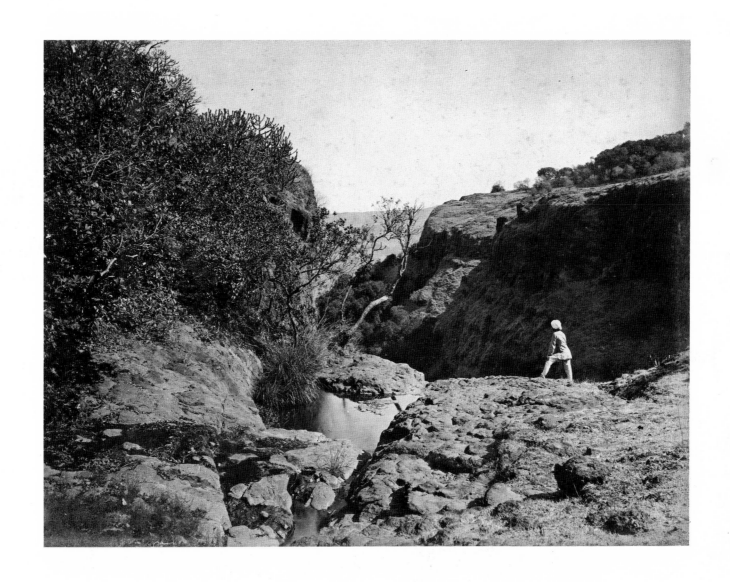

Mount Elphinstone, Mahabaleshwar, 1887.

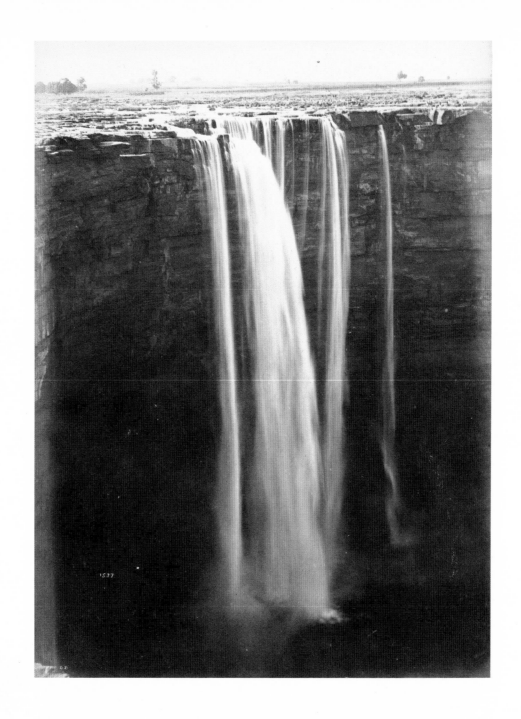

The Chichai waterfall, near Rewa, 1882.

Opposite Sacred banks of the Nerbudda, near Okarnath, 1882.

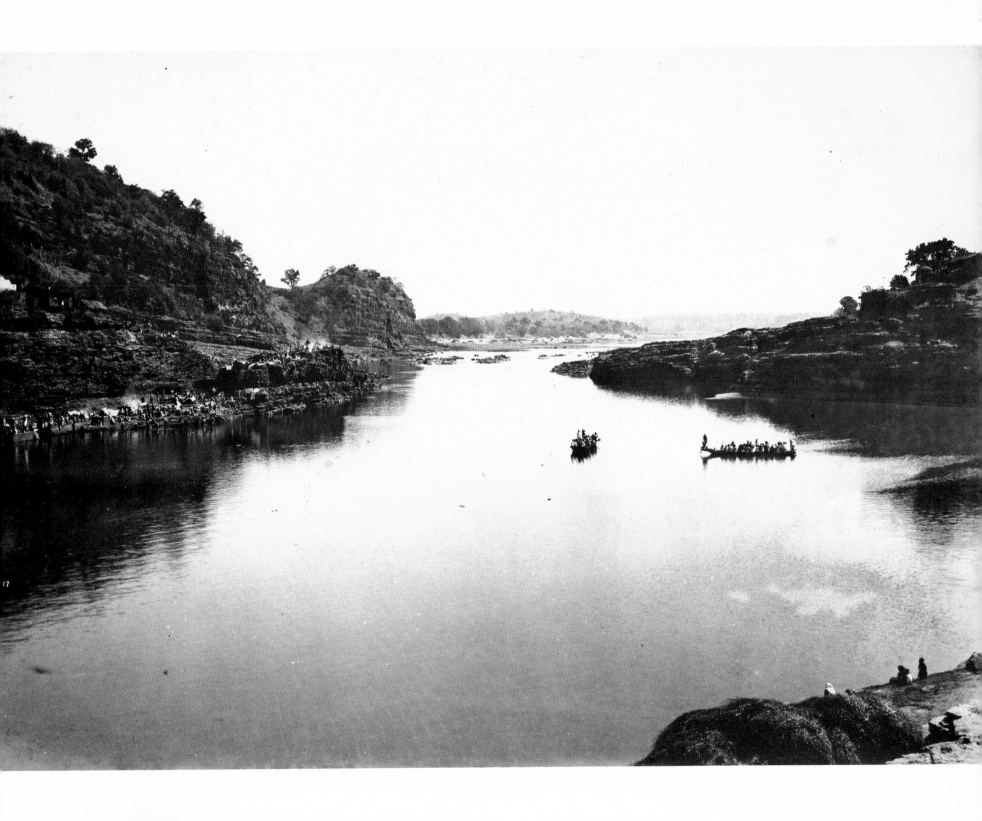

142

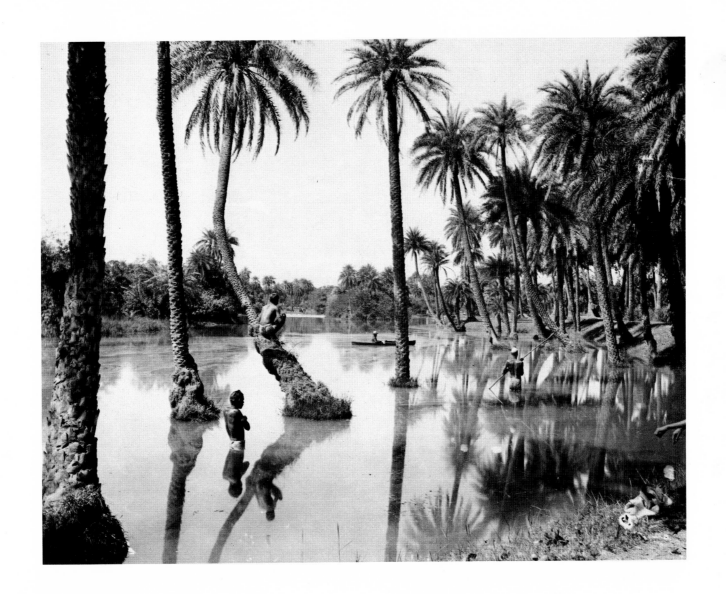

Lake near Indore, 1878.

Opposite South Indian scene, 1888.

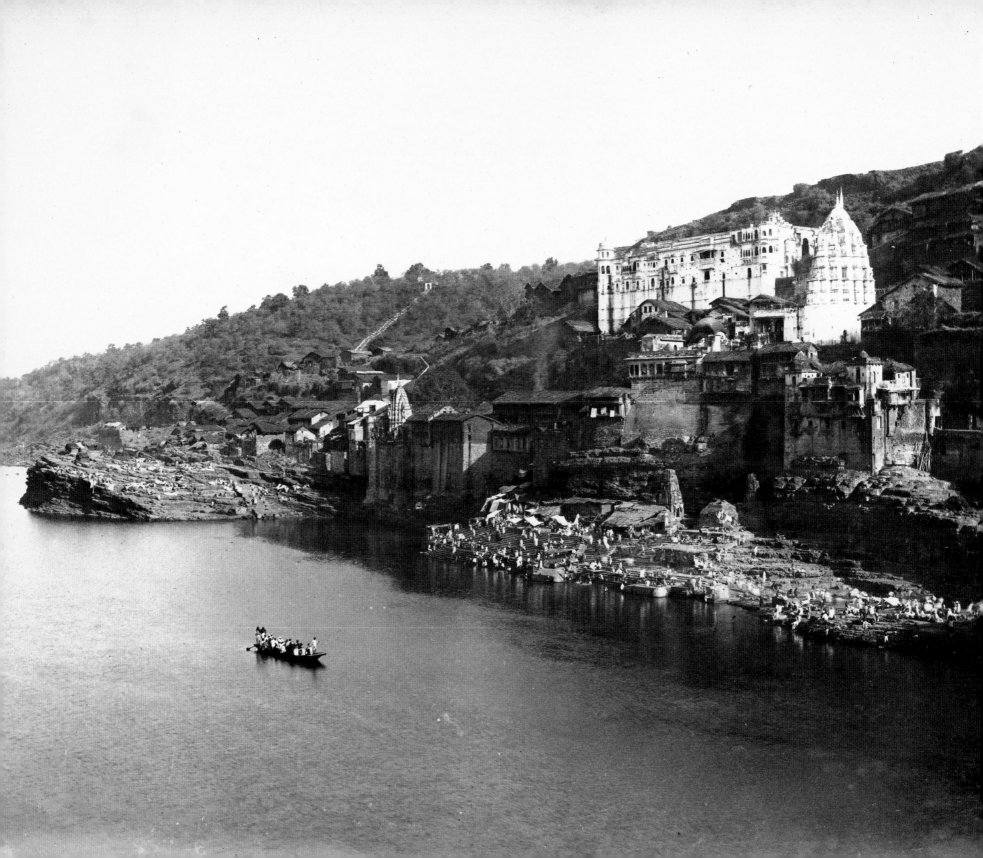

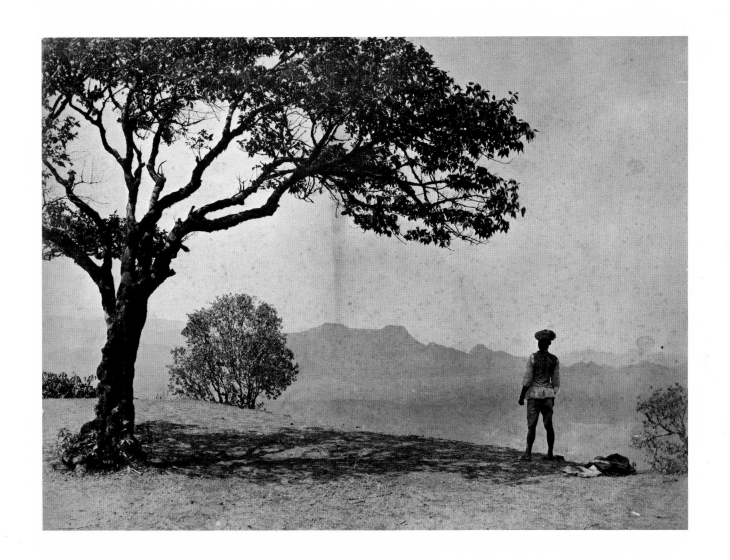

Mahabaleshwar, 1887.

Opposite Holy temple and ghat, Okarnath, 1882.

The Lunger festival in honor of Mohammed Shah, who built much of Hyderabad in the sixteenth century. 30,000 troops of H.H. the Nizam's army parade past the city palace (which was surrounded by 2.5 miles of walls); inside 7,000 servants waited on Sir Mahbub Ali Khan, Hyderabad, 1890's.

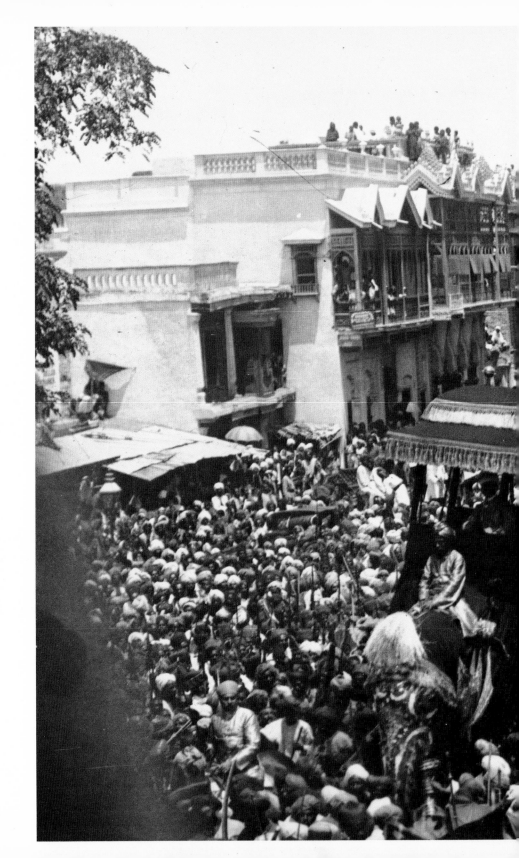

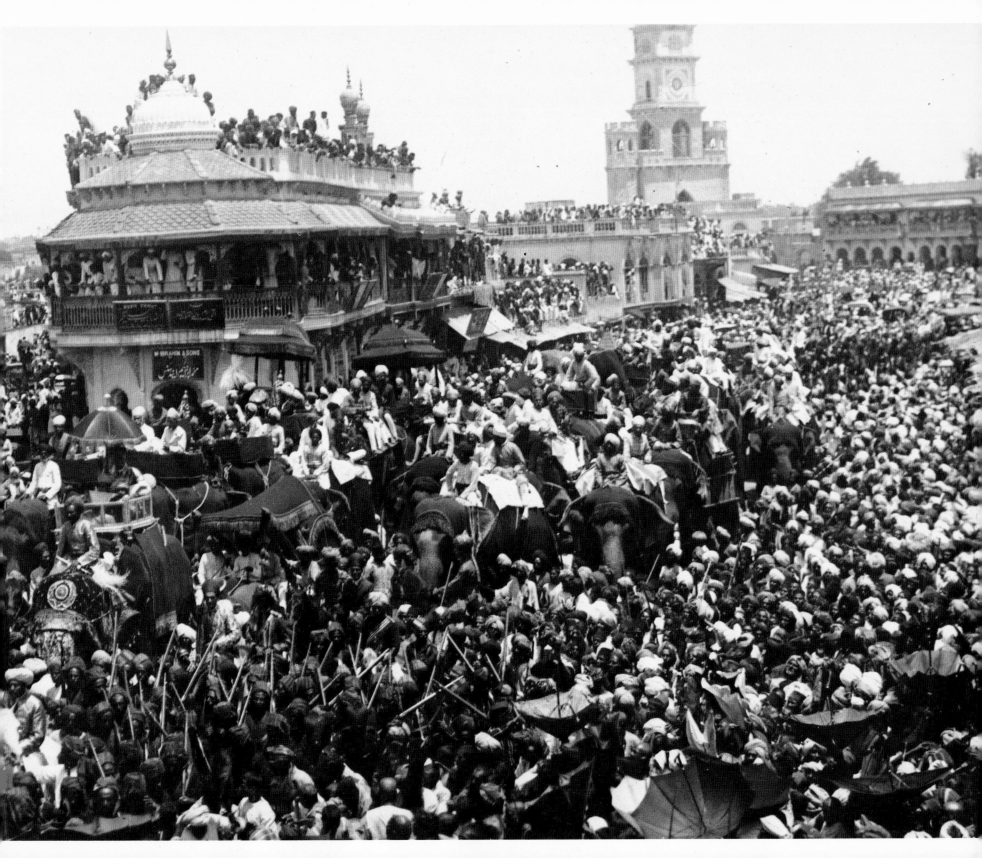

Notes

1. Harriet Ronken Lynton and Mohini Rajan, *The Days of the Beloved*, p. 30.

2. John Lord, *The Maharajas*, p. 24.

3. Wilfrid Scawen Blunt, *India Under Ripon: A Private Diary*, p. 172.

4. *Three Mughal Poets*, translated from Urdu by R. Russell, K. Islam, p. 252.

5. *The Journal of the Photographic Society of Bombay*, January 15, 1855, p. 5.

6. *The Journal of the Photographic Society of Bombay*, 1856, p. 51. The journal states that Merwanjee Bomonjee & Co. was to publish the periodical.

7. T. N. Mukarji, *Art Manufactures of India* (Calcutta, 1888), pp. 30–31.

8. At the time he was engaged in the Public Works Department, Dayal was paid thirty rupees a month, having completed a five-year civil engineering course in three years. Born of parents who were not wealthy nor connected to the pre-British nobility of India, Dayal's appointment as head estimator and draftsman of the Indore Public Works Department shows great and early aptitude.

9. Sir Henry Daly, K.C.B., C.I.E., G.C.O. (1821–95), joined the 1st Bombay European Regiment in 1840 and was present during the Second Sikh War, at the battles at Multan and Gujrat. He raised the 1st Punjab Cavalry (1849) and saw action against the Afridis. In the Great Mutiny of 1857–58, he commanded the Guides Cavalry in their march of 580 miles from the Khyber Pass to Delhi to help relieve the British forces encamped on the ridge. He was also present at the siege of Delhi, the capture of Lucknow, and in the Oudh campaign. Commanding the Central India Horse in 1871, he was made Agent to the Governor-General for

Central India. In 1888, he was promoted to the rank of general. (C. E. Buckland, C.I.E., *The Dictionary of Indian Biography,* Benares, 1971, p. 108.)

10. By the late 1880's, Dayal's stock included photographs of archaeological sites and of places of historical importance, such as those pertaining to the Indian Mutiny. Beyond these were other sets of photographs that Dayal's own firm offered for sale. These included railways (H.H. the Nizam's Guaranteed State Railway; the Indore State Railway and Bhopal State Railways), army maneuvers (e.g., the Mhow Camp Exercise, January, 1884; the Delhi Camp Exercise, 1886; the Secunderabad Camp Exercise, 1887; the Meerut Camp Exercise, February, 1888, and the Poona Camp Exercise, 1893), native types, trades and castes, industries, and, finally, personages of importance, military groups, etc. (see also Appendix). It should be mentioned that the "maneuvers" selection of photographs for sale covers what is probably the most fully documented series of photographs ever taken of a nineteenth-century army taking the field in complete battle array.

11. During Dayal's lifetime, two hundred and fifty of his photographs were accepted by the Archaeological Survey of India. Interestingly, they were not all photographs of monuments or antiquities: the India Office Library (*Archaeological Remains and Antiquities,* Vol. 16, #2582-2606) includes a series of twenty-five negatives and prints of the chiefs of Central India. In Dayal's memoirs he mentions Sir Lepel Griffin's book, *Famous Monuments of Central India* (London, 1886), in which eighty-nine of his photographs appeared. Henry Hardy Cole used eleven of his photographs in *Preservation of National Monuments in India* (Calcutta, 1884–85) and twenty-four photographs in *Photographs of Places of Interest in India.* Notice of this latter book's appearance was made in *The Journal of the Photographic Society of India* (Calcutta, May, 1891, p. 88). In the previous year, the same journal announced in its December

issue that "Lala Deen Dayal, the successful Indian photographer of Indore Central India, intends to bring out a book of Indian Princes—100 native rulers done in the autotype process." Apparently, however, this book of princes was never brought out, but the fragments of this proposed work, done in Central and South India, are published here for the first time. Dayal's first work to be published in a book appeared in *The Chiefs of Central India,* George Aberigh-Mackay (Thacker, Spink & Co., Calcutta, 1879).

12. The Hyderabad government branches that used the photographer's services were the Public Works Department; the Archaeological Department; the Forestry Department; the Registration (Court Notary) Department; the Land Department; the Revenue Department; the Settlement Department; the Mint; the Electricity Department; the Customs; the Agriculture Department; and, finally, the Railway Department.

13. In January, 1892, the following notice appeared in *The Journal of the Photographic Society of India* (p. 10):

> Mr. Lala Deen Dayal announces the opening of a *zenana* photographic studio he has fitted up in Hyderabad. He has placed an English lady of high photographic attainments and well-known there, in charge. As this studio is for photographing native ladies only, special arrangements had to be made to protect them from the gaze of the profane and the stern. So the place is surrounded by high walls, and all day long within this charmed enclosure Mrs. Kenny-Levick, aided by native female assistants, takes the photographs of the high-born native ladies of the Deccan. How lovely! One revels in the thought of the Arabian Nights....

Appendix: Albums Available From
Raja Lala Deen Dayal & Sons
c. 1895

Extract from the firm's catalogue, pp. 110–11:

These albums will be found very useful for drawing rooms, palaces, and for presentation.

1. *Tour of Bundelkhand:* 100 photos, portraits of native groups, durbar (locations) Datia, Sonagir, Rewa, etc. Rs. 175.

2. *Views of Rajputana:* 100 photos, Dilwara Temples (Mt. Abu), Jeypore, Ajmere, etc. Rs. 175.

3. *Views of Mewar:* 30 photos. Rs. 30.

4. *A Souvenir of Indore:* 50 photos, H.H. the Maharaja, horses, elephants, views of palaces and interiors. Rs. 125.

5. *Views of Central India:* 80 photos, Indore, Mhow, Bhopal, Mandi, Sanchi, Rutlam, etc. Rs. 150.

6. *Views of Important and Historical Palaces in His Highness the Nizam's Dominions:* 100 best views in this superior album. Rs. 200.

7. *Delhi Camp Exercise, 1886:* small views of 50 good photographs of the Maneuvers. Rs. 60.

8. *Places of Interest In India:* in 4 volumes, containing 24 photographs each: Vol. 1, Agra, Delhi with Descriptive Matter by Col. Cole, Dir. of Archaeological Monuments in India. [No price quoted; Vol. 1 only published in this projected series.]

9. *The Royal Visit to Hyderabad:* 60 photos of the visit of H.R.H. the Duke of Connaught to Hyderabad—deer shooting, parade of H.H. the Nizam's troops, breakfast at Golconda. Rs. 150 full bound/Rs. 100 half bound. [1889]

10. *H.R.H. Prince Albert Victor's Visit to India:* 50 photos, shikar, tent pegging, breakfast at Khana Bagh, etc. Rs. 100.

11. *A Souvenir of the Visit of H.I.H. the Czar of Russia to H.H. the Nizam's Dominions:* Ellora caves, Daulatabad. Rs. 75 full bound/Rs. 50 half bound. [1891]

12. *The Visit of the Grand Duke Alexander to Hyderabad:* the imperial party on elephants, shikar, etc. Rs. 75 full bound/Rs. 50 half bound. [1891]

13. *The Visit of Archduke [Franz] Ferdinand to Hyderabad* (similar to above albums). Rs. 75 full bound/Rs. 50 half bound.

Bibliography

Blunt, Wilfrid Scawen, *India Under Ripon: A Private Diary.* London, T. Fisher Unwin, 1910.

Brown, Hilton, ed., *The Sahibs.* London, William Hodge & Co., Ltd., 1948.

Fitze, Sir Kenneth, *Twilight of the Maharajas.* London, John Murray, Ltd., 1956.

Gunther, John, *Inside Asia.* New York, Harper & Brothers, 1939.

Hansen, Waldemar, *The Peacock Throne: The Drama of Mogul India.* New York, Holt, Rinehart & Winston, 1972.

The Histories of Some Famous Diamonds. New York, N. W. Ayer & Son, 1969.

The India Leave Book. Hall, Fooks & Hall, Bombay, Thacker & Co., 1945.

Kincaid, D., *British Social Life in India.* London, 1938.

Lord, John, *The Maharajas.* London, Hutchinson & Co., 1972.

Lynton, Harriet Ronken and Mohini Rajan, *The Days of the Beloved,* Berkeley, University of California Press, 1974.

Mehta, Ved, *Portrait of India.* New York, Farrar, Straus & Giroux, 1970.

Munshi, K.M., *End of An Era: Hyderabad Memories.* Bombay, Bharatiya Vidya Bhavan, 1957.

O'Dwyer, Sir Michael, *India As I Knew It. 1885-1925.* London, Constable & Co., 1925.

Robotham, W. A., *Silver Ghosts and Silver Dawn.* London, Constable & Co., 1970.

Russel, R. and K. Islam, *Three Mughal Poets.* Cambridge, Harvard University Press, 1968.

Russell, Sir William Howard, *My Indian Mutiny Diary,* edited by Michael Edwards. London, Cassell, 1957.

Singh, Kushwant, *The Fall of the Kingdom of the Punjab.* Bombay, Orient, Longmans, Ltd., 1962.

Tavernier, Jean-Baptiste, Baron of Aubonne, *Travels in India,* translated and annotated by V. Ball. London, Macmillan & Co., 1889.

Taylor, Colonel Meadows, *The Story of My Life.* Edinburgh, William Blackwood & Sons, 1903.

Tod, Colonel James, *Annals and Antiquities of Rajasthan.* London, Smith Elder & Co., 1829.

Welch, Stuart Cary, *The Art of Mughal India.* New York, The Asia Society, 1963.

Title page design by Michael Flanagan

Book design by Stanley Stellar